Alwyn Crawshaw's
Ultimate
Painting Course

A complete beginner's guide to painting
in watercolour, oil and acrylic

Collins

To my wife June, who has worked with and encouraged me over the last 50 years.

Acknowledgements

I would like to express my thanks to all the students and artists I have met over the years, who have unknowingly helped to make this book possible. To HarperCollins, my publishers for over 25 years, with particular thanks to Cathy Gosling and Caroline Churton, Caroline Hill for designing the book, Isobel Smales for editing it and Sonia Lane for typing the manuscript.

First published in 2006 by
Collins, an imprint of
HarperCollins*Publishers*
77-85 Fulham Palace Road
Hammersmith, London W6 8JB

The Collins website address is:
www.collins.co.uk

10 09 08 07 06
6 5 4 3 2 1

A catalogue record for this book is available from the British Library

Designer: Caroline Hill
Editor: Isobel Smales
Photographer: Howard Gimber

ISBN-13 978 0 00 719282 3
ISBN-10 0 00 719282 7

Colour reproduction by Colourscan, Singapore
Printed and bound in Singapore by Imago

PAGE 1: *Pigeons,* watercolour on cartridge paper, 7.5 x 10 cm (3 x 4 in)
PAGE 2: *French Fruit Stall,* acrylic on acrylic sketching paper, 25 x 22 cm (10 x 8½ in)
PAGES 4–5: *The Blue Door,* oil on canvas, 51 x 41 cm (20 x 16 in)

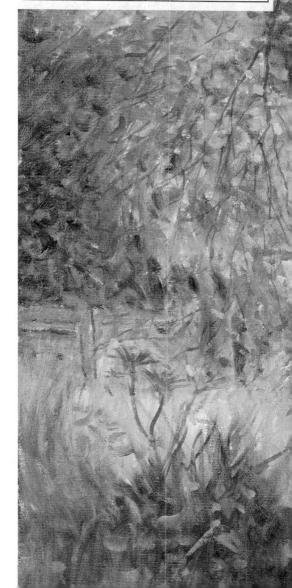

Alwyn Crawshaw's
Ultimate
Painting Course

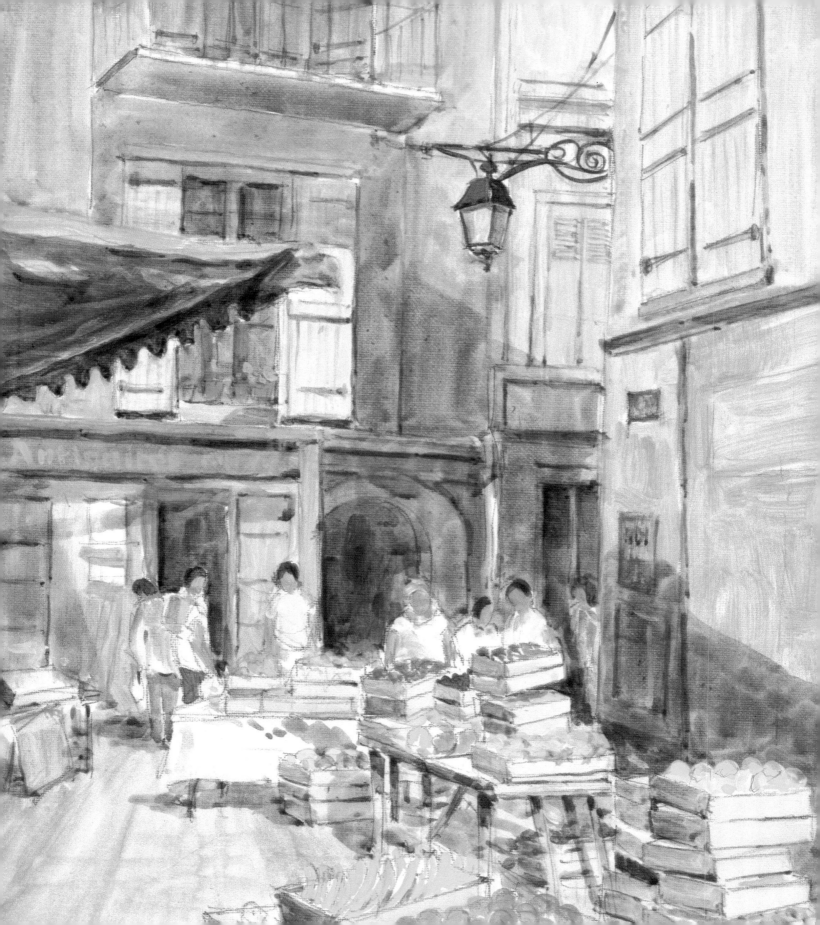

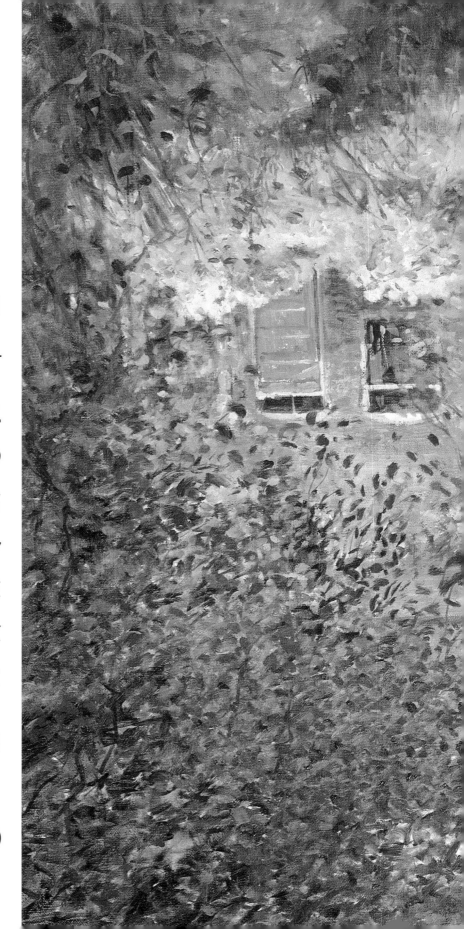

Contents

Introduction

ANYONE CAN PAINT

People say to me, 'I wish I could paint – but I am not an artist.' I ask if they have ever tried, and the answer is usually 'No'! To my next question, 'Can you drive a car?', the answer is often 'Yes'. 'Did you have any driving lessons?' I reply, and the answer again is 'Yes'. My last question is 'Did you have any art lessons, or have you tried painting?' Their answer, said with a hint that they know which way the conversation is going, is usually 'No'! 'Well, how do you know you are not an artist then?' I reply, with a twinkle in my eye.

I believe that anyone can paint. Naturally some people will be ordinary, some good and some excellent. After all, if you learn to drive a car, it doesn't mean you will be a Grand Prix driver. Many people believe you have to be born an artist. Some people do have more natural artistic ability than others, but they still have to learn in the same way as the 'non-born artist'. Their advantage is that the early learning stages are easier. This gives them a bonus, but they still need to work at it and practise.

I have been painting all my life. I have written many books on painting, made television series and given many lectures and painting demonstrations. With over 55 years' experience, and still on the playing field and not a spectator, I hope to excite, help and encourage you as I show you how I work and teach you everything I know.

Over the years I have taught mainly adult students; people who do not have the time that I had in my youth for learning. I started art school at 15 years old and have painted ever

Alwyn Crawshaw sketching outdoors.

Autumn Walk
watercolour on Bockingford 410 gsm (200 lb) Not 36 x 48 cm (14 x 19 in)

Venice
**watercolour on
cartridge paper
28 x 20 cm (11 x 8 in)**

The Greenhouse
**watercolour on
cartridge paper
28 x 20 cm (11 x 8 in)**

since, knowing it to be my lifetime's work. Most amateur or leisure painter students have limited time to learn, especially about the history of art and all the different complex avenues that you can follow. Therefore over the years I have concentrated on teaching the more important aspects of painting and eliminated what I consider to be unnecessary for these students. This is not a gimmicky shortcut to painting – it is a practical way forward, using traditional methods, for people who just want to enjoy painting. Naturally, if you have the time and the inclination to find out, for instance, the life story of Claude Monet, then do. This is another part of art that is very exciting and very interesting, but it is not necessary for you to know to enjoy painting.

HOW TO USE THIS BOOK

Throughout this book I explain certain ways of working; these are not rules that are set in stone. All artists are different and have their own methods. Although I am sure most of mine are universal, I may have one or two 'Alwyn's only'. A student once said to me after I had been demonstrating a watercolour painting, 'I was so pleased to watch you painting. There were a couple of methods you used that I use, and I had wondered if they were correct. Now I am happy because you did them the same way, so it must be OK.' Never worry how you make a certain mark or what methods you use in your painting; if it achieves the result you are looking for, then go ahead.

In the first part of the book I discuss painting and how to approach it, and I answer some of the obvious questions that beginners and more advanced students will ask. Wherever I can I use everyday language and not artistic jargon. Most of my observations on painting are general and apply to most media.

In Chapter 2 I show and explain the different materials for watercolour, oil and acrylic painting, what can be achieved with them and the way I work with them. Then I consider the painting process, including choosing your subject. Next I cover the practical side of painting, with many exercises and stage-by-stage paintings for you to copy.

Estuary Reflections
oil on canvas
41 x 61 cm (16 x 24 in)

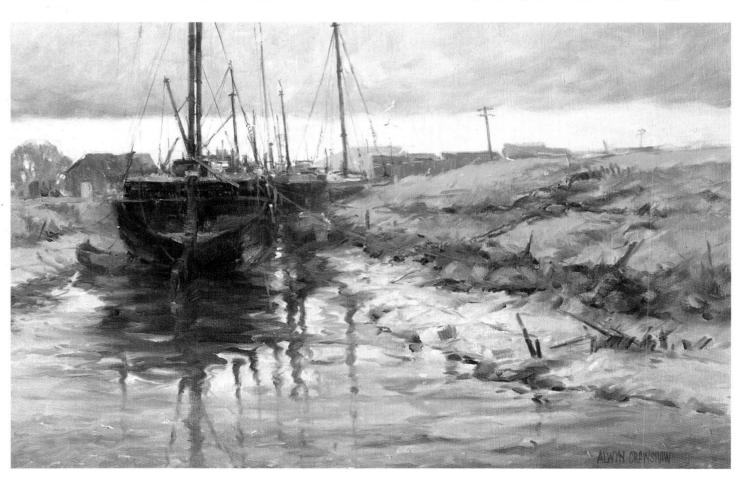

Finally, at the end of the book is a gallery of some of my paintings for you to enjoy.

Many people consider painting to be shrouded in mystery. I have tried to take out the mystery and to simplify the process. If you are a beginner, read the book through first, and then, as someone once said, 'Enjoy an adventure with a paint box.' If you are a more advanced student, remember that you are always learning, and I am sure you will find something within these pages to inspire you further.

My last advice to you is always to aim for the top of the mountain. If you don't make it you could get halfway. But if you aim only for halfway, you may never start. Good luck and happy painting!

Hickling Mill, Norfolk
acrylic on acrylic
sketching paper
38 x 48 cm (15 x 19 in)

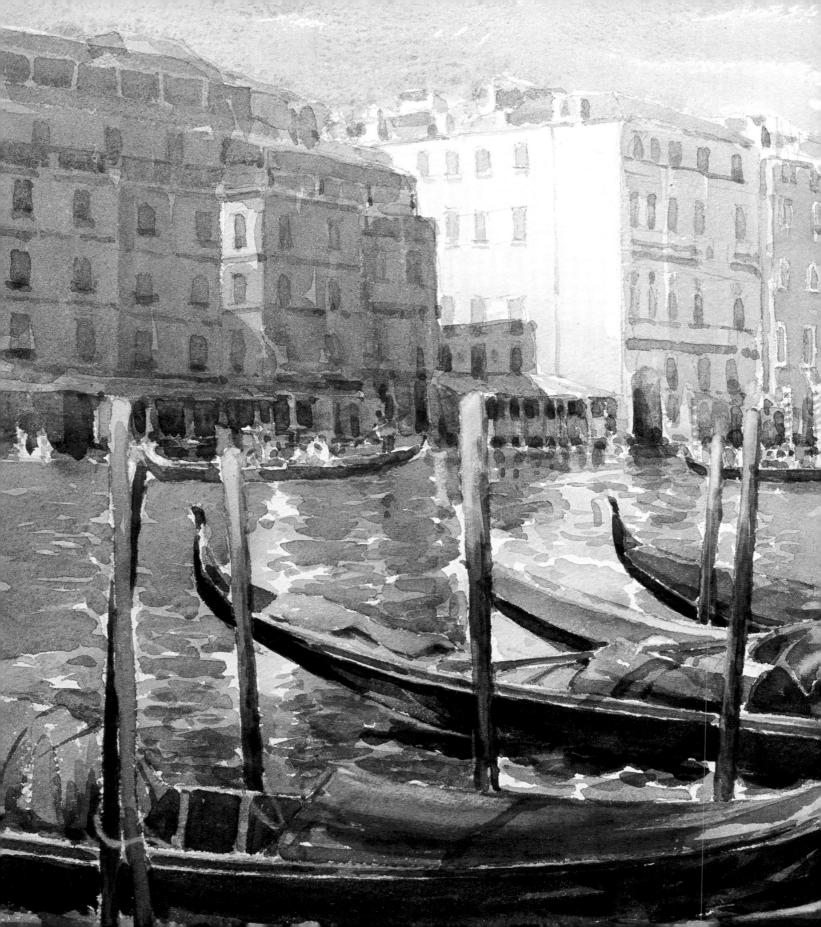

1 Where to start

If you are new to painting you are probably thinking 'Where and how do I start?'. This chapter answers most of the important questions that I am asked by my students. It gives you advice on how to gain confidence, learning from your mistakes, the importance of painting what you see, and how to tell when your painting is finished. If you read through it before you begin you will feel much more confident about taking the first steps.

Komoro City, Japan
watercolour on
cartridge paper
28 x 41 cm (11 x 16 in)

PREVIOUS PAGE:
The Grand Canal, Venice
watercolour on Bockingford
410 gsm (200 lb) Not
35 x 48 cm (14 x 19 in)

ARE THERE ANY RULES?

In art, there aren't any rules. After all, do you remember Damien Hurst's half a cow? – well, perhaps there should be rules! But in this book we are only interested in painting pictures, not venturing to the cutting edge of art. So my experience comes from creating nothing more sizeable or shapely than a 1.5 x 1 m (60 x 40 in) flat canvas. Naturally, within the context of 'painting' pictures, I have experimented and explored many different ways of using different media and ways of creating images, at art school and ever since. It is always good to experiment

and push your creative abilities to extremes; you won't get bored and it can be very exciting and rewarding.

Make your own rules

You make your own rules. You are creating the image that you want. Painting should be enjoyable and not full of dos and don'ts. If you were sitting with a group of artists all painting the same subject in the same medium, the results would all be different. But there is nothing to say that some or all of them have broken the 'rules' to paint their different

Make painting enjoyable. Use any methods you like to create the image that you want.

Tess and Gwen Playing Hide and Seek
oil on primed MDF
30 x 25 cm (12 x 10 in)

pictures. You can use a brush, a brush handle, a sponge, your fingers, a tissue, a piece of rag, a knife or anything you find that gives you the effect you want on the paper or canvas.

Remember, if you find by accident or design a way of achieving an effect that you like, use it. It will give your paintings a personal touch, and show your painting character. But don't look for this character – it will evolve naturally.

Learn your craft

However, there are some basic 'rules' to get you on your way, especially for the practical side of painting, i.e. learning how to work with a particular medium, when and how to apply paint to paper or canvas; simply learning the craft. But even the application of the craft has its 'no holds barred' artists. In the latter part of the last century some artists threw their brushes away and rode bicycles on wet painted canvases on the floor, or dragged nude female models over them, or threw paint at the canvas. So where have all the rules gone? Well, in this book the only rules that are included are there to help you to paint pictures with confidence!

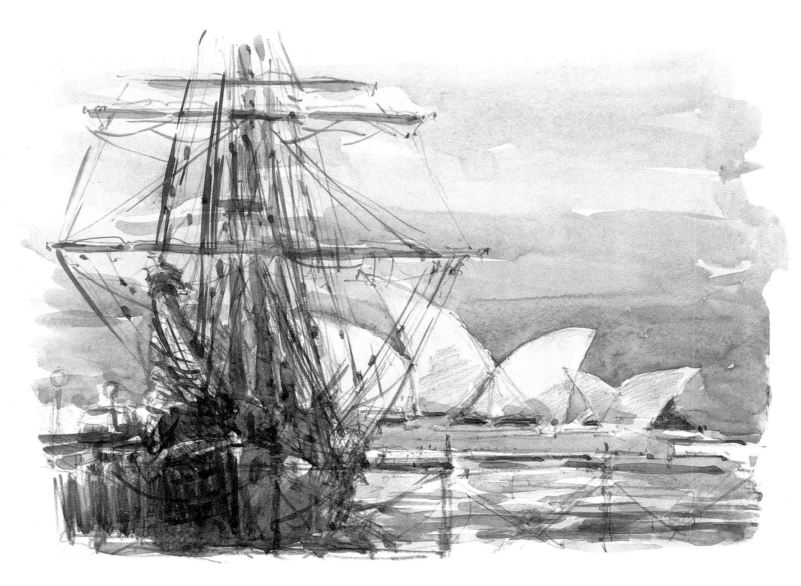

The Opera House, Sydney, Australia
watercolour on cartridge paper
20 x 28 cm (8 x 11 in)

INSPIRATION

Inspiration is the starting point for all paintings. When you sit in front of your subject you must want to paint it more than any other. You must feel excitement inside you and a tremendous exhilaration when you start painting – this is inspiration.

Naturally we all feel this to different degrees and in different ways, but whether we mentally jump for joy while we look at a subject, or physically sit down quickly to start, that is the way forward. Inspiration will help you to paint to the best of your ability. This is true of any level of artist and subject, whether painting in the studio or outdoors.

Imagine looking at a scene that held no interest for you at all and being asked to paint it. It would be very difficult to give it your undivided attention, you could get very bored doing it, and the result would be a very ordinary painting. You must always give yourself every opportunity to paint a great painting, and inspiration is one of the most important ingredients.

When my wife June and I were in Sydney Harbour, Australia, I saw an old sailing ship in front of the Opera House (left) and felt that familiar tingle at the back of my neck. I was very excited. I wanted to paint it – I was inspired! It was early evening and the light was fading. I worked fast and enjoyed every minute of it. I suggested the rigging on the ship very freely. Notice how the dark indistinct shape of the hull does not interfere with the distinctive shapes of the Opera House in the distance.

When we were in Japan we visited the old part of Japan's former capital city, Kyoto. I had never before seen telegraph poles and cables stretched across a street in such a jumble of disorganized shapes and lines. I could see a painting – I was inspired. I found a wall to sit on and started. I left painting the telegraph poles and the cables until last. With the rest of the painting finished, I was concerned that I might spoil it if the poles and cables were not drawn correctly. But with such a complicated mass of lines, who would notice if one or two were not in the correct place? So I picked up my brush and enjoyed the freedom of painting them in.

The third painting shown here was done on the Norfolk Broads, near where June and I live. It was a late summer's afternoon, and as I looked across the marshes the atmosphere was warm, peaceful and inviting. The ruins of St Benet's Abbey on the right gave a perfect focal point. I was inspired. Notice how simply the cows and distant windmill are painted. This helps them to merge into the landscape and not to distract from the Abbey.

Poles and Wires, Japan
**watercolour on
cartridge paper
20 x 28 cm (8 x 11 in)**

St Benet's Abbey, Norfolk
**watercolour on
cartridge paper
20 x 28 cm (8 x 11 in)**

HOW DO WE LEARN?

Learning should be a process of excitement and enjoyment. Unfortunately, our image of learning is created during our school days, and many people are put off by the thought of it. But stop and think. As I have explained, there are no rules – except yours. There is no maths or Latin master standing behind you, no exams to sit, the time is yours and, above all, you are keen to paint. So be positive. Time you take to learn is time practising, and you are practising to reach your aspiration to be a great artist (remember the mountain). Naturally you will need some stepping stones, and the following are all ideas to help you to begin the process.

Tips for learning

Learning to paint is learning to see and, more importantly, it is learning to observe. Learn what you consider you need to produce your paintings. You don't need to have the technical knowledge of palette knife painting, for instance, if you never intend to paint that way.

We can all learn from the old masters, and new ones for that matter; they have all built their skills on what was done before them. When I was at art school we were encouraged to copy old masters' paintings as one way of learning. Today with modern printing technology there are many prints of the masters' art to copy. Remember not to copy their signatures!

You can join an art group, most towns have them, where you will be mixing with other artists in a stimulating environment. You can also learn from the many teaching videos and DVDs on the market. Choose an artist who paints the way you would like to, and study how his or her paintings are achieved.

There are many excellent tutorial books to choose from, and these can become friends for life. Visit local exhibitions, and look closely at the paintings to see how different effects were achieved.

Learn from your mistakes

Accept the fact that you will always make 'mistakes'. If you study these you will learn from them. Never be afraid of criticism; it is a great teacher. Remember, your critics, who don't have to be artists, see your painting with a fresh eye and can see things that you have missed because you are too involved with the painting.

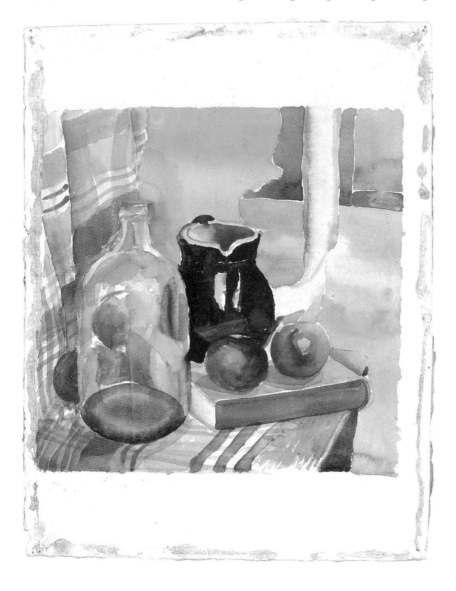

Art School practice
watercolour on watercolour paper 300 gsm (140 lb)
28 x 25 cm (11 x 10 in)
This painting was done to practise wet-on-wet: look at the glass jar.

I sketched these elephants at
the zoo using a 2B pencil and
watercolour.

Never forget that we are always learning.
Every painting, even every brush stroke, is a new
experience that consciously or subconsciously
teaches us a little more, gives us more
experience, builds our confidence and ultimately
helps us to produce better paintings.

Most importantly of all, before you begin,
make yourself comfortable, with enough
light and time. Don't start ten minutes before
the children come home from school!
Remember when you sit down at your easel
or board that you are the master, you are in
charge of your painting, so relax, and
enjoy learning.

FEAR OF STARTING

I don't think there is an artist who hasn't at some time looked at a blank piece of paper or canvas and decided to have a coffee, or made some other excuse for a delay before starting, as the blank surface sends a thousand questions through his or her mind. One of the prime stumbling blocks, especially for the beginner, is the fear of spoiling a pristine piece of expensive paper. You may also have second thoughts about whether this is the best size for the painting and for the subject, whether it is the right subject, whether you really want to paint it, or whether you have been inspired. There are many negative thoughts that can stop the brush touching the paper, and many excuses to do a 'war dance' round it, as June and I always call it.

Make a mark

Once you are in front of your easel, there is only one way to start – make some marks with your pencil (watercolour) or brush (oil). This, although it sounds obvious, means you have made a conscious and physical effort to start,

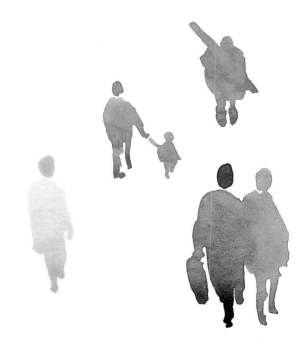

ALWYN'S TIP

Don't worry about spoiling a pristine piece of paper or canvas; be bold and make some marks on it.

Covering this canvas with paint prior to starting gave an interesting surface on which to begin painting.

and you no longer have a pristine surface in front of you that can be spoiled. If you are painting a watercolour, draw a few basic positional pencil lines. Be bold with them, not timid, and let them be seen. Look at my watercolour opposite. You can see the pencil lines showing through. Some students seem to believe that the pencil lines should not be seen through a watercolour painting. Pencil lines showing on a watercolour are acceptable; in fact they give structure and substance to many watercolour paintings. I believe they can also show that the artist is confident and in control.

When starting with oils you can draw on the canvas with a brush, or, even better, decide on a colour, mix it with plenty of turpentine (white spirit) and scrub with a large brush any odd shapes, or the important main shapes, or cover the whole canvas if you want. By adding more turpentine to the paint you will get lighter areas. See my canvas prior to starting a painting (left). The pristine canvas has now gone and you have an interesting surface on which to make a start.

Itea, Greece
watercolour on cartridge paper
20 x 28 cm (8 x 11 in)

Detail reproduced actual size showing pencil lines.

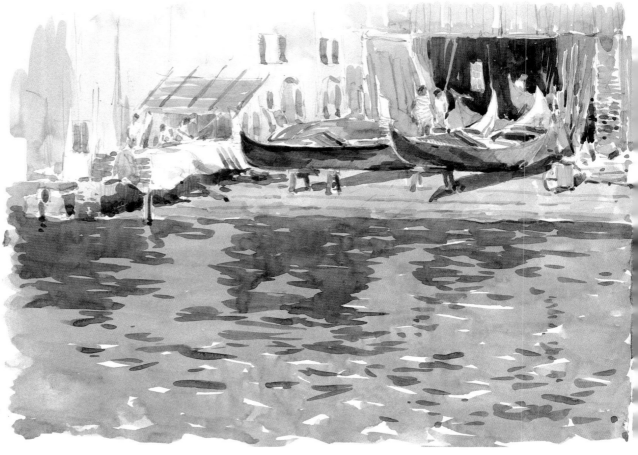

The Gondola Boatyard
watercolour on
cartridge paper
28 x 41 cm (11 x 16 in)

MAKING MISTAKES

Never throw away a failed painting or sketch; it is a valuable teaching tool. It will always be a visual reminder of what went wrong, or what you could have done a different way, and what not to do again! Painting an area black when it should be blue, or using a large brush for a passage of painting when it could have been done better with a smaller brush, are mistakes, but a failed painting is not made up of 'mistakes', it is simply the best that the artist can achieve with his or her ability and experience at that time.

To put it simply, your first painting will be made up of many 'mistakes'. From these you can learn how to avoid them, until you reach a stage where there are only a few on a painting. I don't believe any artist can paint a picture without 'mistakes'. But remember that mistakes are not things that have gone wrong; they are passages of painting that could have been done in a different or better way. In fact the artist is always changing things in a painting as he or she progresses through to the finish. That is the way a painting is done.

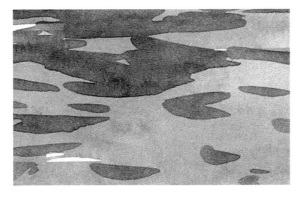

Detail of the water showing how little white paper I left to show reflected light.

The result at the end of a long sketching day. The sketch is hard to understand.

In the painting opposite I made a 'mistake' when I was sketching the gondola repair yard in Venice. It is one of the easiest mistakes to make when working in watercolour. I didn't leave enough unpainted white paper in the water. Once you have covered the paper with paint, there is no way of getting white paper back! Obviously I was not concentrating hard enough.

On another occasion June and I had been on a sketching trip all day and I was feeling a little tired. Walking back I saw some boats being moored (above). I just had to do a pencil sketch of them. But I couldn't concentrate well and I found it hard work. Eventually my common sense took over and I gave up. The result is not a good sketch, and the information is not drawn clearly enough to enable me to work from it at

home. This is not the first time I have made the mistake of doing that extra last sketch of the day. We must try not to let our enthusiasm take over at the wrong time!

So never throw any painting or sketch away, for whatever reason. Put them in a drawer and forget them. In the future, months or years later, get them out and compare them with your current work. You will be surprised and pleased at your progress, and part of this is due to learning from your own work and mistakes.

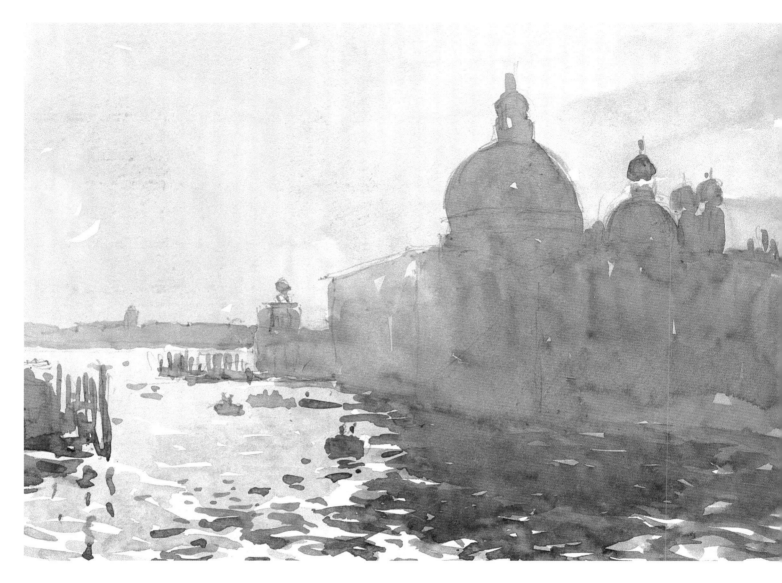

Early Morning, Venice
**watercolour on
cartridge paper
20 x 28 cm (8 x 11 in)**

DOES SPEED MATTER?

I am often asked by students, 'Do I have to paint quickly? My friend paints much more quickly than I do, so am I slow?' The answer is that you are not slow and your friend is not fast. All artists have their own natural speed of working, in the same way that some people write, do the gardening or read a book faster than others. However, there are times when painting fast is an advantage. When you work outdoors it is always important to work as fast as you can.

A rain shower can come from nowhere, or the object you are painting can be moved; a boat, a car, people and of course the clouds and the tide won't stop, even for an artist! Work at your own speed, but concentrate on working at your fastest speed.

The half-hour exercise

There is a traditional exercise for all artists that does require fast painting. You simply paint a subject against the clock. I have always

encouraged students to do this half-hour exercise. It is an excellent way of learning. I have explained more about it on pages 120–23.

Opposite is a sketch I did of the Grand Canal in Venice at sunrise. Speed was essential. As the sun comes round the corner of the left-hand buildings (not in the sketch) you are blinded by the reflected light on the water and the sun in the sky. You have only minutes to create an impression of the scene. Because of this I drew a simple silhouette of the buildings and mixed some basic colours in my paintbox ready for starting. When I judged the time was right, I crossed my fingers, filled my brush with watery paint and did the sketch very quickly, and I thoroughly enjoyed the experience.

The painting below shows Mount Fuji in Japan. Because of heavy clouds coming across the sky that can cover the mountain in minutes, I decided to make it a half-hour exercise. Notice the telegraph poles again: they seem to be everywhere in Japan! By the time I had finished, Fuji was engulfed in cloud. In Japan it is called the 'shy mountain' because it is nearly always covered by cloud. I had been lucky again!

Use speed only when it is needed

I work on some large paintings over a period of weeks rather than minutes, painting in the studio at my natural speed. Even after I have 'finished', I may change many things, working on and off for weeks – this is how I produced the oil painting on p.48. Work fast only when there is a good reason for doing it, otherwise work at your natural speed.

ALWYN'S TIP

Speed is not essential – but it helps when painting outdoors.

Mount Fuji, Japan
watercolour on cartridge paper
20 x 28 cm (8 x 11 in)

KEEP THINGS SIMPLE

Don't overwork your painting, as this can make it look laboured. The 'sparkle' will have gone and it could become a very ordinary painting. I was always taught at art school that a painting must look as if it has been simple and enjoyable to do. This relaxes the onlooker, who will find the painting easy to look at.

Even a complex subject can be painted with this effect. This doesn't mean that a simple painting is easy, and that it doesn't take much thought or experience to do. On the contrary, it usually needs more experience and more thought to achieve.

See the overall picture

Learn to simplify everything you can in a painting. For instance, if you were painting a field, you wouldn't paint every blade of grass. You would achieve the impression with perhaps just a few brush strokes. Always keep the simplified image uppermost in your mind as you paint. Your own style of painting and your experience (which, remember, you can't get without practising!) will guide you.

ALWYN'S TIP

Don't try to paint every blade of grass. Keep it simple.

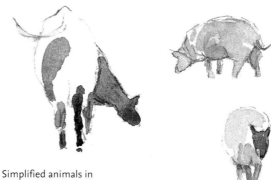

Simplified animals in watercolour, actual size.

Above is a very simple watercolour of a cow, a pig and a sheep. Try painting these. This is the way to learn to simplify. Take just one object and practise. Working this way will also increase your confidence, and confidence will make your painting easier and your paintings better.

The oil painting I did of Pin Mill in Suffolk (right) is painted very simply. The wooden structure on the estuary mud is a dark silhouette against a light, complicated background. Below right you can see how I simplified this background. This helped to make it recede and it gave depth to the painting. Also notice how simply the mud and water are painted.

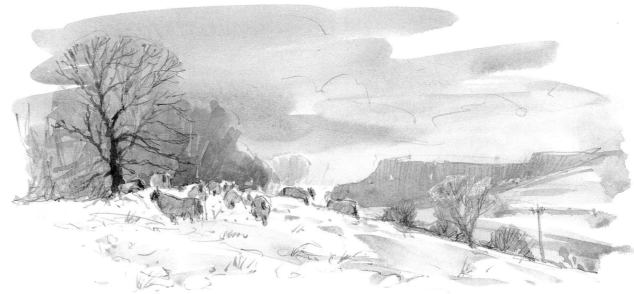

Look how simply the sky and distant hills are painted.

Late Afternoon, Pin Mill
oil on canvas
30 x 41 cm (12 x 16 in)

Detail reproduced actual size
showing how I simplified the
objects in the background of
this painting.

CONFIDENCE

Doubting yourself as an artist is one of the best ways to prevent yourself from becoming one. You must believe in what you can do or all your efforts will be wasted. You will have set your sights on reaching only halfway up the mountain and not got past the first boulder!

I am sure some of you will be saying, 'It's easy for you – you are an artist'. But I am only an artist because through practice and the desire to become an artist I overcame any doubt in myself, and therefore gained confidence, which wasn't done overnight.

Gaining confidence

How do you gain confidence? I am sure you have many attributes already that will help build your confidence in your painting. For instance, you can write, therefore your hand is capable of working with a brush and a pencil. Where and how to move them comes from knowledge you can get from this book and from practice. Some people have a natural colour sense, others a feel for design, and some people have a natural creative flair. So build on the abilities you already have.

For a beginner the main obstacle to overcome that contributes to a lack of confidence is mastering the technical part of painting; knowing the correct materials to use and the ways to use them. Even the thought of going into an art shop, not knowing what to ask for, can deter people from starting. But don't worry. I have explained all this in later chapters. Once you have some knowledge of the basic techniques you will find you are full of confidence and raring to progress and paint some masterpieces. Confidence comes from knowledge, which in turn comes from practice, and failure? There isn't such a thing!

I did this painting of a bicycle in my studio. I had been painting a large watercolour all day and although I was ready to finish for the day I was in a very 'watercolour confident' mood. I had sketched this old bike leaning against an outbuilding in the garden weeks earlier, and had intended to paint it. Then I saw the scene after a snowfall and I was even more inspired. I took a photo of it for information before the snow melted. It was just the subject that I felt I could paint and enjoy painting at the end of a good watercolour session.

Because there is a lot of unpainted paper representing the snow, the brush strokes had to be right first time, so that I didn't paint over the white paper. I was very happy with the result. But if I had not felt confident I don't think I would have attempted it. For some watercolour painting, confidence is just as important as a good brush or knowing how to mix colours.

This was drawn straight in with my rigger brush. If I hadn't felt confident, it would have looked terrible. Remember, confidence comes with practice.

*And I looked Out
of the Window*
watercolour on Bockingford
500 gsm (250 lb) Not
36 x 48 cm (14 x 19 in)

Detail showing how I left
white paper to represent
the snow.

These trees were painted the same size as they are reproduced here, using one continuous brush stroke, with no drawing.

PAINTING WHAT YOU SEE

Technique is simply a particular way of applying paint on to the working surface (ground). If you are a beginner you have to learn different techniques to get you started. But as you practise you will find your own methods developing. This is when your own personal style will begin showing through.

At a painting exhibition you often hear someone say, 'I like his technique'. They simply mean they like the way the artist has applied the paint to the picture. This is one way you can recognize an artist's work; it has his or her painting signature.

When you are working indoors, either from a sketch, a photo or your imagination, to be able to paint a tree, for instance, you will have developed a technique. That technique is the only way you know how to paint a tree, because you are not outside copying one from nature. That is fine, but here is a way to extend and develop your technique. When you are outdoors sketching or painting, don't rely on technique; in fact forget it and paint what you see. Let nature show you the technique to use. Avoid using the easy and tried way, let your subject itself give you more insight.

Look at the trees above. They are painted in the middle distance using a very simple technique that evolved when I was painting in the studio. The sketch above right shows very clearly, although exaggerated, a technique in pencil sketching where you use regular lines for

ALWYN'S TIP

Paint what you see – not what you know. Let nature guide your technique.

This sketch, done with a 2B pencil, uses regular lines for shaded areas.

This sketch was also done with a 2B pencil, but this time I sketched what I actually saw.

shaded areas. Now look at the sketch below: this is the same scene, but this time I sketched what I saw. Although when working from nature your work will in some ways look different from your studio work, it will still have your personal signature.

The oil painting above was done outdoors. I was sitting at the bottom of my garden,

copying what I saw. Techniques that you learn indoors can help you when you are painting outdoors, and painting from nature can inspire you and give you ideas of more ways to paint when you are in the studio.

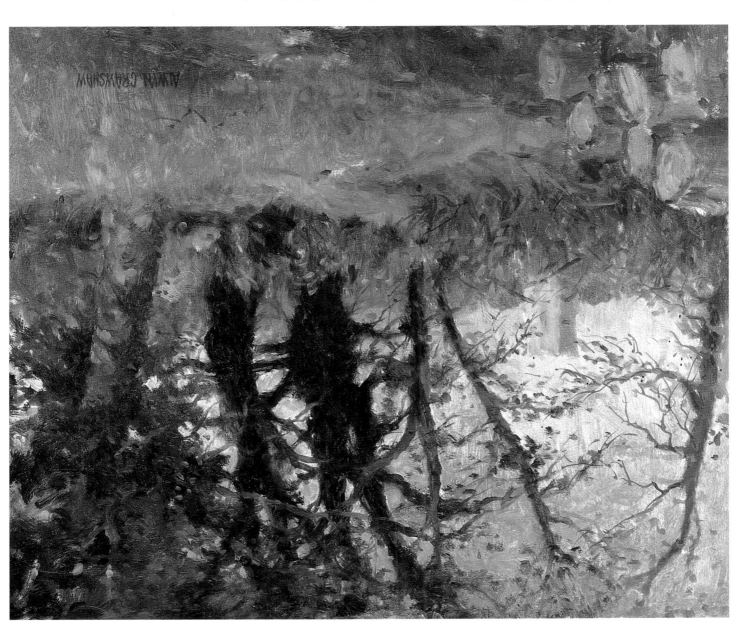

Hickling Church, from the Paddock
oil on primed MDF
25 x 30 cm (10 x 12 in)

WHEN IS A PAINTING FINISHED?

A painting is finished when you are happy with it. If you have achieved what you set out to do, then there is no point in working on it any further. My golden rule is this: when you get to the stage in a painting where you believe it is finished, but start looking for more things to do to it, then it is finished. If you work any more, you will overwork the painting and spoil it.

Don't look for things to do

Many times during a hands-on teaching class I have helped students to progress with their picture towards a finished point. Some of the students' paintings, especially watercolours, look great, and I tell them to leave them – they are finished – even though there may be half an hour to the end of the session. As usual, at the end of the session we discuss all the work in front of the class, and it's amazing how many of the students I told to stop have looked for 'things to do' because there was more time, and consequently have overworked their painting, making a great painting into a mediocre one. It doesn't follow that the more work you put into a painting the more finished it is.

ALWYN'S TIP

If you are looking hard for things to do on a painting, it's finished.

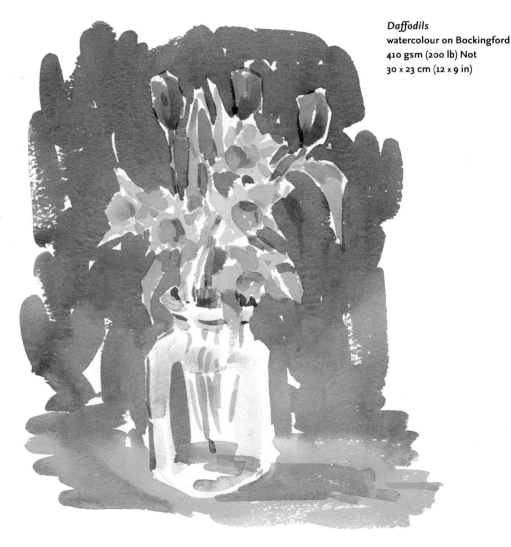

Daffodils
**watercolour on Bockingford
410 gsm (200 lb) Not
30 x 23 cm (12 x 9 in)**

Know what you are aiming for

It is important to decide how you want to paint your picture and therefore what type of image you are looking for.

In the painting opposite I decided to paint a very 'free'-style watercolour of daffodils. To paint something like this you must have a mental image of the finished result in your mind's eye, and you must know how you intend to paint it. You will not overwork it, because you will know when you have achieved the result you want. Some people might say

that the painting is not finished, but these are people who prefer more precise work and more detail in a painting.

The oil painting above has more work and more detail and would satisfy such people. In the gallery world I have found it is easier to sell this second kind of painting than the 'free'-style ones. But remember, paint what you want to paint, and when you are happy that you have achieved the result you are looking for, stop: don't fiddle and overwork it. Your painting is finished.

Late Afternoon, Trafalgar Square, London
oil on primed MDF
30 x 41 cm (12 x 16 in)

2 Tools and techniques

Entering an art supply shop is like walking into an Aladdin's cave overflowing with a tremendous selection of different art materials. Unless you know what you want it can be very daunting, and may put you off painting before you have even started! This chapter shows you the basic materials you will need to make a start, and describes many ways of using them so that you can practise and become confident in all the basic techniques.

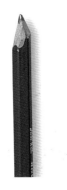

Don't use a pencil sharpened like this!

Sharpen your pencil to a long point, using a knife.

PENCILS

The pencil is perhaps the most important tool that an artist uses. Fortunately we are all very familiar with it, having used it since our school days. The pencil is very versatile, but to get the most out of it, as always, you must practise. This can be done almost anywhere, any time. Use inexpensive copying paper, the back of wallpaper, or old used envelopes. The object is to 'scribble' and see the variety of marks you can make using a pencil.

First, which pencil? There are 11 grades of pencil, with different lead consistencies (hard and soft). The middle one – not hard, not soft – is called an HB pencil; this is the general purpose one for everyday use. The hard grades start at 2H, getting harder through to 6H. The soft grades start at 2B, getting softer through to 6B. I use a 2B pencil for 80 per cent of my work and a 3B and HB for the rest. An HB is good for more 'detailed' drawing work. I always use the 2B and occasionally the 3B for all my sketching. Because the 3B is softer it is ideal for quick sketching where a lot of shading is needed; for example, a fast-moving cloudy sky, see below. You will not get any creativity or response from your pencil if you sharpen it like the one far left! You must have a long, tapered point sharpened with a sharp knife.

The photos opposite show you three ways of holding your pencil and the resulting effects. Try copying the exercises on the right: they will give you an idea of what effects you can achieve with a 2B pencil.

3B pencil on cartridge paper. This soft pencil is ideal for sketching where a lot of shading is needed.

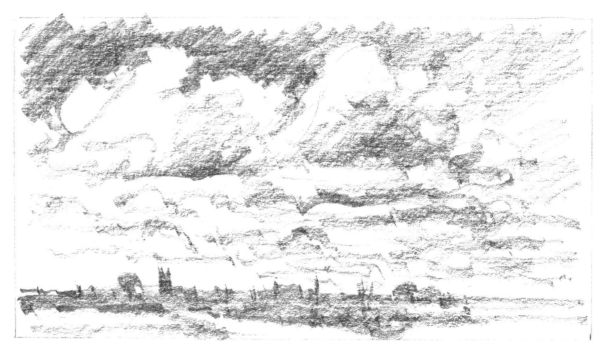

PREVIOUS PAGE:
Plenty of Snow!
watercolour on Bockingford 410 gsm (200 lb) Not
35 x 48 cm (14 x 19 in)

34 ALWYN CRAWSHAW'S ULTIMATE PAINTING COURSE

The 'short' hold position that you use when writing gives you most control.

The 'long' hold drawing position allows versatility over a large area.

Experiment with your 2B pencil and see what it can do. Try copying these sketches. Notice where I have rubbed out a thick line with a plastic eraser (middle left). You can get many different effects this way. Never be afraid to use an eraser, it is an important tool and part of an artist's basic equipment.

By using the 'flat' drawing position you can work large shaded areas with fast, free, broad strokes using the long edge of the lead.

WATERCOLOUR MATERIALS

Watercolour has the great advantage that it requires no complicated equipment, making it ideal for the beginner. Even when painting outdoors, the basic essentials are light and easy to carry (see page 47). Here I discuss the materials and basic techniques to get you started with watercolour.

Choosing and using papers

Which paper should you choose? There are many papers on the market. On the opposite page are photographs of the different papers I use in this book, reproduced actual size. I have also shown you what effects a pencil and a brush stroke of colour give you on each type of paper.

The grade of the paper simply means the texture of the working surface. Traditionally there are three different surfaces: Rough, Hot-pressed and Not. Rough means that the surface is rough; Hot-pressed (HP) means the surface is very smooth; and Not (sometimes called Cold-pressed or CP) indicates that the surface is in between rough and smooth – by far the

most commonly used. The weight of the paper (the thickness) is determined either by grams per square metre (gsm, increasingly the most common method) or by calculating how much a ream of paper (500 sheets) weighs. So, if a ream weighs 200 lb, the paper is called (with its manufacturer's name and surface type), for example, Bockingford 200 lb Not. This is equivalent to 410 gsm. You will find that a good weight of paper to work on is 140 lb (300 gsm).

Bockingford watercolour paper is an excellent inexpensive paper. It is one of my favourites, which I have used for many of the watercolours and demonstrations in this book. Waterford watercolour paper has a 'harder' surface and can take more punishment from the brush. It is good for painting wash over wash, without pulling up the previous wash. Cartridge paper is a drawing paper, but I find it excellent for painting on, up to A3 size (28 x 41 cm (11 x 16 in)). I use it for all my outdoor pencil and watercolour sketching. I use a spiral-bound sketchpad of 150 gsm (70 lb) paper.

Experiment using these papers. You may find you enjoy using one more than the others.

ALWYN'S TIP

Use only one or two papers if you are a beginner. Get to know them and how they react to your way of working.

The Causeway, Hickling
watercolour on Bockingford 410 gsm (200 lb Not) 38 x 51 cm (15 x 20 in)

OPPOSITE:
These watercolour surfaces (grounds) are reproduced actual size. The pencil I used was a 2B.

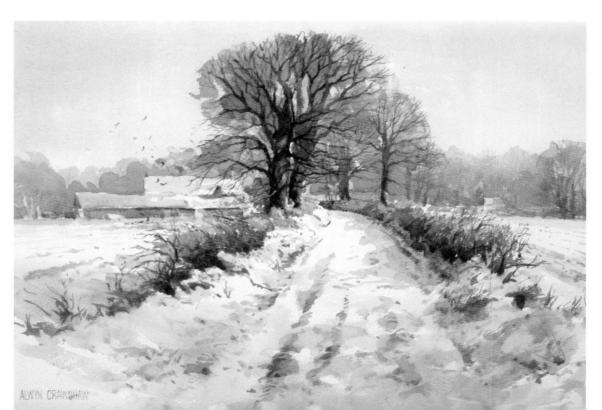

ALWYN CRANSHAW

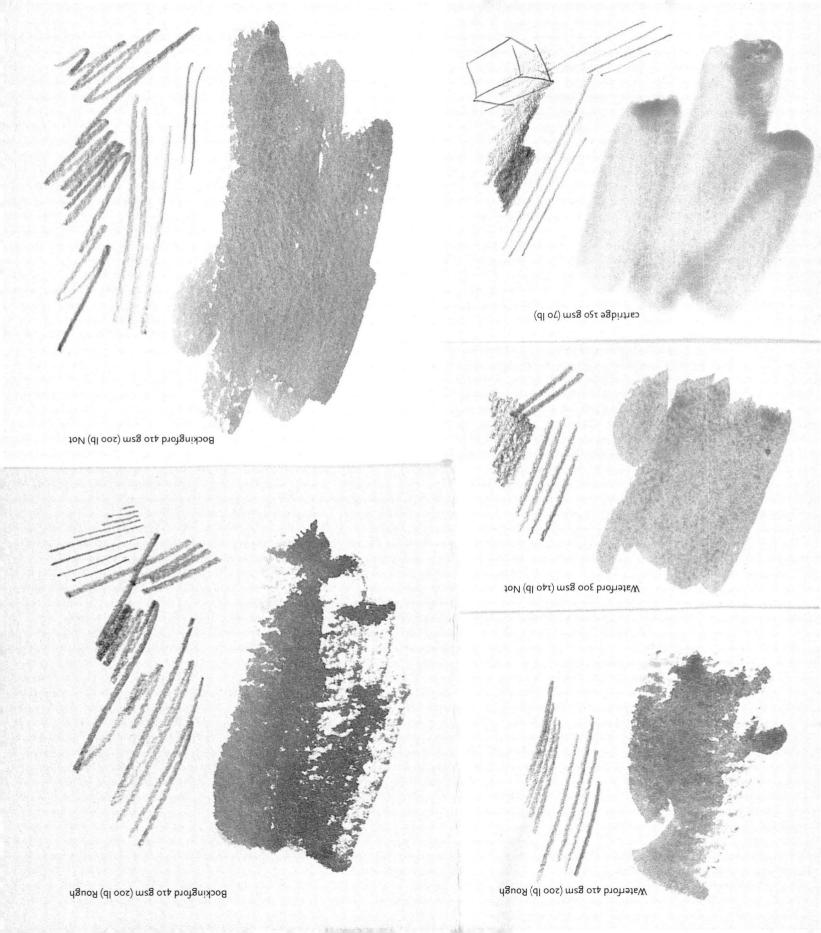

cartridge 150 gsm (70 lb)

Bockingford 410 gsm (200 lb) Not

Waterford 300 gsm (140 lb) Not

Bockingford 410 gsm (200 lb) Rough

Waterford 410 gsm (200 lb) Rough

Choosing and using colours

When we look at nature there are thousands of different colours, but these can all be mixed from only three basic colours – the primary colours of red, yellow and blue. There are, of course, different reds, yellows and blues, which help you to mix a range of different colours.

The colours I use in my watercolour paintings are shown on the right. My main primaries, which I use for about three-quarters of all my paintings, and the exercises in this book, are Alizarin Crimson, Yellow Ochre and French Ultramarine. I use smaller quantities of three other primaries: Cadmium Red, Cadmium Yellow Pale and Coeruleum. Although you can mix shades of green, orange, purple, brown and so on, you can also buy them ready mixed, but in this book I use only one ready-mixed colour: Hooker's Green Dark. There is nothing wrong with using ready-mixed colours, but by using only the primaries you learn how to mix the colours you want, which is important.

Predominant colour first: One of the most important rules for mixing colours is to put the predominant colour that you are trying to create into the palette first (with water). For instance, if you want a yellowish-orange, you must put the yellow into the palette first, then carefully add a little red. If this is done in reverse, the red overpowers the yellow and you obtain a reddish-orange. When you are mixing colours for the exercises in this book, it is important to note that the first colour I specify (in the captions or in the text) is usually the predominant colour of the mix, with other colours added in smaller amounts.

Lighter colours: Because watercolours are transparent, the only way to make a colour lighter is by adding more water, to dilute the

pigment (colour). To make a colour stronger, just add more pigment.

Some simple colour mixing: In the colour chart on the opposite page, I have started with my three primary colours and mixed them to show you some of the basic colours that can be obtained by mixing just two or three primary colours. Then I have added Hooker's Green Dark, and also shown how to mix a 'black'. I don't use ready-mixed black and I recommend that you don't, especially if you are a beginner: it can become a short cut to darkening colours but it will only make them 'dirty', and you will not learn how to mix it by using only your three primaries.

Buying colours: Watercolours come in two forms: tubes and pans. I recommend using pans if you are a beginner, as you do not pick up as much paint on your brush as you do with the very soft paint squeezed out of a tube, so you have more control. I always use pans.

The best quality and more expensive paints are called artists' quality. I have used these throughout the book. Those a grade lower are called students' quality. Daler-Rowney's students' Aquafine colours are excellent.

Alizarin Crimson

Yellow Ochre

French Ultramarine

Primary colours

Cadmium Red

Cadmium Yellow Pale

Coeruleum

Another set of primary colours

Hooker's Green Dark

A ready-mixed colour

The colours I use for most of my watercolour painting.

A watercolour half-pan and tube of paint

Cadmium Yellow Pale + Alizarin Crimson

Cadmium Yellow Pale + French Ultramarine

Alizarin Crimson + French Ultramarine

Cadmium Yellow Pale + Alizarin Crimson

Cadmium Yellow Pale + French Ultramarine

Alizarin Crimson + French Ultramarine

+ Alizarin Crimson to make the orange darker

+ French Ultramarine to make the green darker

+ French Ultramarine to make the purple darker

+ more Alizarin Crimson

+ more French Ultramarine

+ more French Ultramarine

+ more Alizarin Crimson

+ more French Ultramarine

+ more French Ultramarine

+ more water to make the last orange lighter

+ more water to make the last green lighter

+ more water to make the last purple lighter

Hooker's Green Dark Alizarin Crimson

French Ultramarine

Alizarin Crimson

Yellow Ochre French Ultramarine

'black'

Hooker's Green Dark + Alizarin Crimson

+ French Ultramarine

Alizarin Crimson + Yellow Ochre + French Ultramarine

+ water

+ water

+ water

Choosing and using brushes

A brush is perhaps the most important tool of all. It is the brush that makes the marks on the paper, creating the painting and giving it your individual style.

The traditional and best quality general-purpose watercolour brush is a round sable. Sable brushes will last for years, and they are at the top of the price range. Brushes made of man-made fibres (nylon) are also available, and these are much less expensive. Daler-Rowney's brand name is Dalon. These are excellent brushes. The larger sizes do not hold as much water (paint) as the equivalent sable brushes, but still perform exceptionally well.

Choosing a brush is like choosing your paper; find the one that suits you. There are brushes of many different shapes and sizes on the market, and the variety can be overwhelming. The number of the brush reflects the size of the brush hairs. I use three brushes: a No.10 and a No.6 round sable, and a rigger No.2. If you are a beginner, I suggest you start with these three brushes, sable or nylon. Once you are confident, try any others that take your fancy, but you can only learn what they can do if you practise.

ALWYN'S TIP

Any 'mistake' can be used in its own right as a technique. It is only a mistake if you are trying to achieve a particular technique and fail.

Trying out your brushes: Try out the brush strokes on the page opposite. These have been done in watercolour using a No.6 brush, but you can practise them with your No.10 brush too. These basic strokes are also used for oil.

Each photograph shows two arrows. These are used throughout the book to show you the direction of movement of the brush. The solid black arrow shows the direction of each individual brush stroke, and the outlined arrow shows the direction in which the brush is travelling over the paper. For example, in the second photo the brush stroke is going downwards and the brush is moving across the paper after each stroke.

I have also shown examples where the planned effect has not been achieved – where it 'went wrong'. The captions explain what has happened in each case.

A: This is the general purpose stroke. Your brush will make this line naturally when you paint horizontally using medium pressure.
B: Vertical strokes are important in paintings, so they must become second nature to you. If you are painting a line up to about 5 cm (2 in) long, vertical or horizontal, move only your fingers; for longer lines you must move your whole arm, or the line will start to curve.
C: This looks like a doodle but is one of the most important strokes. I use it to fill irregular areas and move on to other areas, filling them all with colour. You can change colour as you work. The secret is to keep your paint watery.
D: Moving only your fingers, copy the first five strokes, starting at the top with very little pressure, then putting the pressure on. Do the reverse for the next five.
E: Load the brush and paint a continuous line, at the same time varying the pressure. Make sure you have enough paint on your brush to finish the whole stroke.

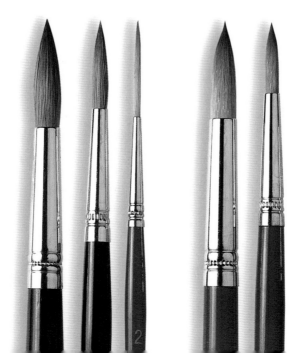

Brushes actual size, from left to right: No.10 round sable brush, No.6 round sable brush, Dalon rigger No.2, Nylon (Dalon) No.10 round, No.6 round.

A

WHAT WENT WRONG
In the second line I lost concentration and the brush wobbled; this is easily done.

B

WHAT WENT WRONG
When the strokes on the right were done the arm wasn't moved down so the lines curved.

C

WHAT WENT WRONG
In the bottom line the paint was allowed to dry, therefore the 'wash' was not a consistent tone.

D

WHAT WENT WRONG
In the strokes on the right too much water was used in the brush.

E

WHAT WENT WRONG
There was not enough paint in the brush to finish the bottom line, which turned into a dry brush stroke (see page 46).

WATERCOLOUR TECHNIQUES

There are many watercolour techniques that you can learn and many others that I am sure you will invent for yourself. Practise the techniques shown here on inexpensive paper. The more you practise the more familiar you will become with applying watercolour to paper.

The watercolour wash

Learning to paint a wash (an area of paint) is the most fundamental and important lesson in watercolour painting. A wash can cover the whole of your paper or an area only the size of a small coin. The secret of applying a wash is to use a lot of water. The most important rule before you start is that the paper must always be at an angle when you work – not flat. The paint must be allowed to run very slowly down the paper. Some artists use an easel and have the paper upright, which is fine for those with experience who work freely and accept that the paint can run out of control down the paper at any time during the painting. However, to begin with you must learn how to apply and control watercolour, so your paper must be at just a slight angle.

Flat wash: Mix plenty of watery paint in your palette and load your large brush. Start at the top left-hand side of the paper if you are right-handed, taking the brush along in a definite stroke. Don't rush. When you get to the end, lift the brush off the paper, bring it back to the beginning and start another stroke, running this into the bottom of the first wet stroke. Add more paint to your brush as you need it; don't let it get dry.

Because you mix the paint first and don't add any more water or paint to the mix, the colour remains the same throughout the wash. When it is dry, the colour density should look the same all the way down.

Flat wash

WHAT WENT WRONG
Here the paint was allowed to dry in places between strokes and the brush strokes were not uniform.

WHAT WENT WRONG
The paper was at too steep an angle. The paint ran down, stopped at the bottom of the wash and then broke away. A fabulous design if you want it – and if you could repeat it!

WHAT WENT WRONG
There was not enough water, giving a dry brush effect – good if it is what you wanted!

Graded wash: Start in exactly the same way as for the flat wash but add more clean water to the paint in the palette for each brush stroke as you work down. This will make the colour weaker, and the wash will grow gradually lighter in colour.

Graded colour wash: Work just the same way as the graded wash, but instead of adding water, add different colours to your palette. This will change the colour of the wash as you progress. This wash is ideal for painting cloudless skies.

Graded wash

Graded colour wash

I used a variety of different washes when I was painting this sketch.

Wet-on-wet

Paint a wash and immediately paint over it with another colour. Putting a wet colour onto another wet colour allows the colours to mix and merge together. It is difficult to control the results; experience will help. Wet-on-wet is great for painting cloudy skies. You can't get a crisp edge with this technique.

Wet-on-dry

Paint a wash, but this time let the wash dry before you paint over it with a second colour. Painting over a dry area of paint always gives a crisp, clean edge.

Wash-on-wash

Paint a flat wash. Let it dry, and paint over it with the same colour. Because watercolour is transparent, it will look darker. Let the second wash dry and now paint over both; the wash will be darker still. This is how you can build up tonal values in a painting.

Wet-on-wet

Wet-on-dry

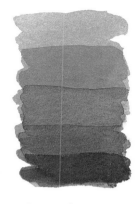

Wash-on-wash

WHAT WENT WRONG
The first wash was only damp, not wet.

WHAT WENT WRONG
The first wash was not completely dry.

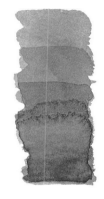

WHAT WENT WRONG
The first three washes were fine, but the next washes were not left to dry.

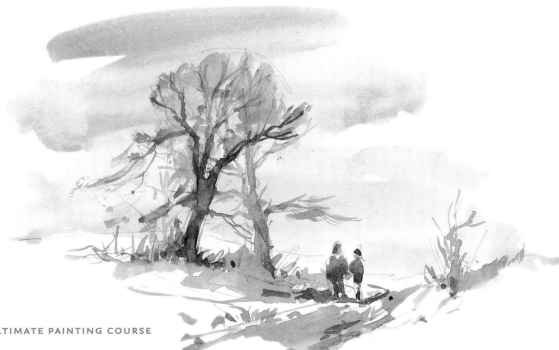

The tree trunks in this sketch were painted wet-on-dry.

Lifting out (tissue)

Lifting out (brush)

Filling in

WHAT WENT WRONG
The paint was too dry to allow the paint to be lifted out.

WHAT WENT WRONG
The brush strokes were not blotted out with a tissue quickly enough. Blot out immediately you finish the brush stroke.

WHAT WENT WRONG
The outline was allowed to dry. When the filling was done, the wash went over the dry outline and made it darker than the inside.

Lifting out (tissue)

Removing wet paint from an area, lifting out, is a normal practice in watercolour. The paint must be very wet to give you the best results. A paper tissue is most commonly used. You can get a very creative uncontrolled shape if you screw up a piece of tissue and just press it into the paint, as I did here. Experiment and try different ways of using a tissue.

Lifting out (brush)

If you want to lift out once the paint is dry, you can use a brush. The stiffer the bristles the more you can remove the paint. Brush clean water into the dry paint, then immediately blot with a tissue. Some colours lift out better than others and the type of paper can also make a difference to the result.

Filling in

If you paint the outline of an area first then paint up to it to fill it in, the outline must still be wet. That way the outline and the filling-in colour will merge together, and you will have a solid area.

This sky was painted wet-on-wet.

Soft edges

In most paintings there are soft and hard edges on objects. This makes things appear round or curved or just soft edged. Look at the round tube (below). Start painting the outside of the tube on the left; add water and paint to the right hand side. To show the inside of the tube, start on the left with water and then add paint. This needs plenty of practice. Now try the blue panel underneath the tube, starting with paint and finishing with water. The oblong panel has a soft top edge. Paint this by softening the painted top edge with water.

Shadow colour

A mix of French Ultramarine, Alizarin Crimson and a little Yellow Ochre gives a good shadow colour. Because watercolour paint is transparent it allows the underneath colour to show through. In the example on the left, this shadow colour has been painted over yellow and white.

Dry brush

This technique is used constantly in different ways throughout a painting. With your brush almost dry, drag it across the paper. It will hit and miss the paper, leaving flecks unpainted. The rougher the paper the better the results will be. It is a very good technique for painting sparkling sunlight on the surface of water.

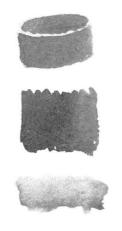

Soft edges

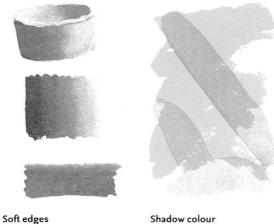

Shadow colour

Dry brush

WHAT WENT WRONG
Not enough water was added when painting the inside or the outside of the tube. The same problem can be seen with the blue panel. The opposite happened with the panel at the bottom; there was too much water applied.

WHAT WENT WRONG
There was too much pigment in the shadow colour, making it too dark and less transparent.

WHAT WENT WRONG
There was too much watery paint on the brush.

BASIC KIT FOR WATERCOLOUR

The following is a summary of the basic equipment you will need to start painting with watercolour.

- 2B pencil.
- Putty eraser for rubbing out pencil marks. This kind of eraser is kinder to your watercolour paper.
- Craft knife for sharpening your pencils.
- Paint box (colours on page 38).
- Brushes: No.10 and No.6 round, rigger No.2.
- Jam jar for a water holder.
- Pads of watercolour paper and cartridge drawing paper.

If you feel restricted once you gain experience, then go to an art supply shop and buy whatever takes your fancy. But remember, you must become the master of whatever you buy to get the best results – so don't go overboard.

OIL MATERIALS

One of the beauties of using oil paints is that 'mistakes' can be painted over or wiped off and you can start again. You do not need a great deal of equipment to get started (see page 57).

Choosing and using different surfaces

The traditional painting surface (support) for oil painting is canvas, but other less expensive surfaces are also available. If you are a beginner I suggest that you practise on these.

When you buy a canvas it will have been primed (sealed to prevent the oil in the paint from seeping into the surface beneath) and stretched ready for use. You can buy canvas by the length and stretch it at home, but I do not recommend this for a beginner.

Opposite are photographs of some painting surfaces, reproduced actual size. I have applied some paint and pencil marks to help show you the grain of the surfaces. All absorbent surfaces, such as paper or hardboard, will need to be primed before you paint on them by applying two or three coats of household emulsion paint or acrylic primer, obtainable from art supply shops. If you don't prime the surface, the paint will not 'stick' and could be rubbed off; it will also not spread so easily.

Oil sketching paper (rough and smooth grain) is one of the least expensive supports and is great to work on. You can buy it in pads or sheets, primed and ready to paint on. I use Waterford watercolour paper, primed with three coats of acrylic primer, for paintings no larger than 41 x 30 cm (16 x 12 in). I also like MDF board, primed in the same way; it has a very smooth surface, quite different from canvas. Canvas boards are simply boards with canvas, already primed, stuck on to one side. A canvas panel has a simulated canvas surface on board. Try out a range of different supports until you find one that you prefer.

You are Always Watching the Birds
oil on canvas
61 x 91 cm (24 x 36 in)

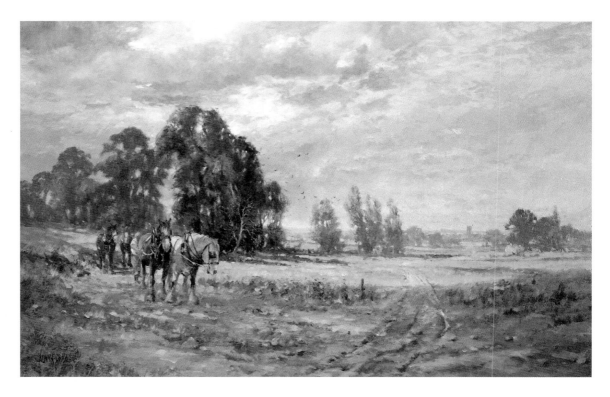

OPPOSITE:
These oil painting surfaces are reproduced actual size. The pencil I used was a 2B.

oil sketching paper

canvas panel

canvas board

Waterford 410 gsm (200 lb)
Rough, acrylic
primed

MDF, acrylic primed

canvas, primed

Choosing and using colours

Oil paint comes in tubes, and you squeeze it on to a palette, then mix the paints with a brush. As you mix you add a medium to your paints. Some mediums thin the paint, others make the paint move (spread) more easily; some speed up the drying of the paint, and a medium is also used for washing brushes.

The medium I use to mix or thin oil paints is called low-odour thinner. It is ideal for working with indoors as it doesn't smell of turpentine. I use Alkyd Flow medium to help spread the paint, if needed, although for me its best use is to speed up the drying time of the paint. Oils can take a great deal of time to dry, and a good tip is to mix some Alkyd medium into your white paint with a palette knife before you start painting. Because white is used for most colour mixes, this speeds up the drying time. You can also put some Alkyd medium into a dipper on your palette to add to paint at any time.

It is difficult to say just how much Alkyd medium you need to add to speed up the drying time. It is helpful to make a test sheet. Start with 15% Alkyd medium added and paint a small area, say 5 cm (2 in) square, and check the drying time. Then try adding a little more of the medium and repeat the test. Naturally, the thicker the paint, the longer it takes to dry, but with experience you will get to know how much to add to get your desired result.

Like watercolour there are two qualities of oil paint: artists' quality and students' quality. The former are more expensive. I have used mostly Georgian oil colours (students' quality) for the work in this book, and I find them excellent. The colours I use are illustrated on the right. As you can see, I paint with two reds, two yellows and two blues – the primaries. I also use two greens (including Cadmium Green, an artists' quality colour), Raw Umber and Burnt Sienna. I suggest you start with these and experiment with others later if you want to.

In general the rules for mixing colours are the same as in watercolour, except for one very important difference. Oil colours are opaque, so to get a lighter colour you add white. If you are mixing a light colour, your first colour must be white, to which you add your predominant colour, then the others. Use the exercises on the opposite page to practise mixing colours.

Crimson
Alizarin

Yellow
Ochre

French
Ultramarine

Primary colours

Cadmium
Red

Cadmium
Yellow

Coeruleum

Another set of primary colours

Cadmium
Green

Viridian

Raw
Umber

Burnt
Sienna

Ready-mixed colours

Titanium
White

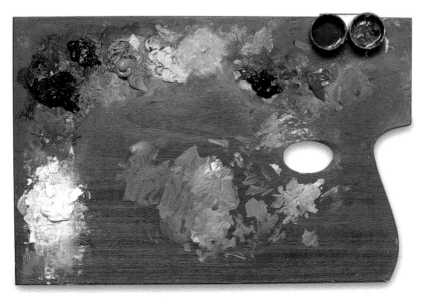

This is one of my palettes.
Above are the colours I use.

Cadmium Yellow **+** Crimson Alizarin

Cadmium Yellow **+** French Ultramarine

Crimson Alizarin **+** French Ultramarine

Cadmium Yellow **+** Crimson Alizarin

Cadmium Yellow **+** French Ultramarine

Crimson Alizarin **+** French Ultramarine

+ white

+ white

+ white

+ more white

+ more white

+ more white

+ more white

+ more white

+ more white

Yellow Ochre

Cadmium Red

Coeruleum

white

'black'

Viridian

Raw
Umber

Cadmium Green

Choosing and using brushes

There are three basic brush shapes used for oil painting: round, filbert and flat. There is also a 'short flat'. I prefer the flat brush for general work. The traditional oil painting brush is made from hog bristle, but man-made (nylon) bristles are also used – not necessarily to replace the hog bristle brushes but to allow the artist more scope. For detailed work you will need a small round sable or nylon brush. Series of brushes for oil colours start at No.1 (the smallest) and usually continue up to No.12, the largest. I have used Daler-Rowney Bristlewhite B48 Series Nos 2, 4 and 6 in this book. You will also need a palette knife (see page 56).

While you are working, you wash your brushes in turpentine (white spirit) and wipe them on a rag. When you have finished, keep them clean by occasionally washing them with soap. Put some soap in the palm of your hand and rub a brush into it under cold running water. Thoroughly rinse and dry the brush before your next painting session.

The photographs on the opposite page illustrate some different ways to use your brush, and the effects you can achieve. Try these out for yourself.

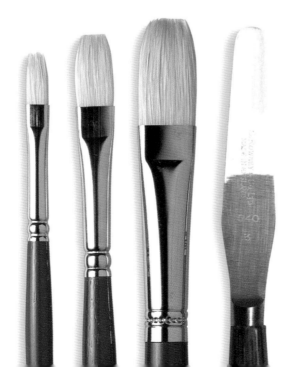

A selection of Bristlewhite flat brushes B48 Series, and a palette knife.

Flat hold: This is a way of holding the brush that is ideal for covering large areas. It gives you a lot of freedom, but not much control.

Long hold: For areas of more controlled painting, hold the brush as you would a pen or pencil, but not near the bristles. You will find you hold your brush like this for most of your painting. This allows you control over the brush strokes, but enough movement of the brush to have freedom and movement over the canvas.

Short hold: For detailed work hold the brush exactly as you would a pencil or pen, and this time hold it nearer the bristles. This gives greater control for painting thin lines or delicate detail.

Scumbling: Scumbling is a way of working a thin, uneven layer of paint over another colour on the canvas, which allows the under colour (which must be dry) to show through, giving a very free and broken effect. I use this brush stroke for underpainting, painting skies and areas of broken foreground. You will find many uses for this effect.

Painting edges: Where an area of colour stops and joins another colour, there has to be an edge. I have shown three ways of creating an edge. The hard edge is simply a crisp edge; it makes an accent, a definite demarcation between two colours or areas. The soft edge is a way of making the edge not too prominent. One of its uses is to form the edge of something soft – an animal, for instance. To create a soft edge, work the brush over the desired edge, so that it picks up the paint from the next colour. Finally, a lost edge is where an edge merges into another surface, so that in effect there isn't an edge. To create a lost edge, exaggerate the soft edge.

Short hold

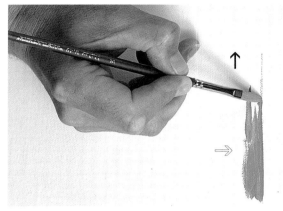

Lost edge

Long hold

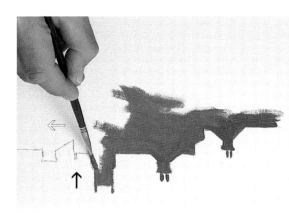

Hard edge

Soft edge

Flat hold

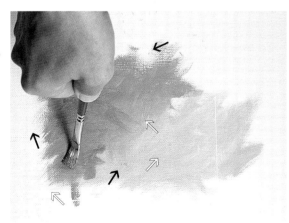

Scumbling

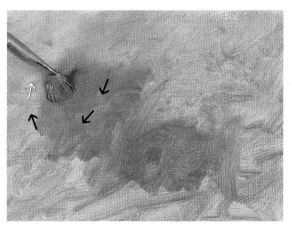

OIL TECHNIQUES

Here I show you a few basic but important techniques, some of which can be used with other media: for instance, scumbling and dry brush can be used with acrylics too. Practise each of these to get familiar with them. As before, I have shown what can go wrong with the techniques.

'Turpsy' underpainting or drawing

This is a very common way to begin an oil painting. Mix a little paint (any colour except white) with turpentine or low-odour thinners and draw your picture, and also paint in the dark areas. This will give you a good starting point for your painting.

Rag scumbling

This is the same as scumbling with a brush, except that you use a rag around your finger to apply the paint. Make sure the underpainting is dry before you start.

'Turpsy' underpainting

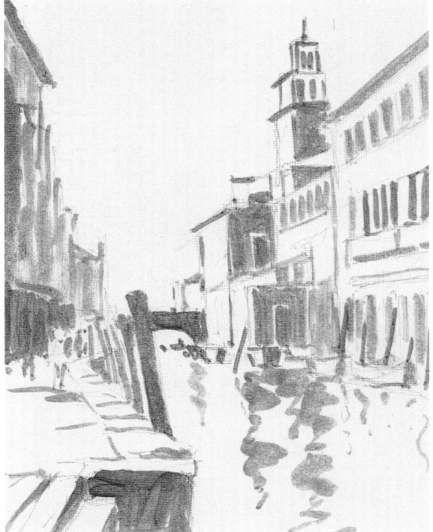

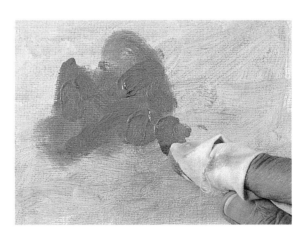

Rag scumbling

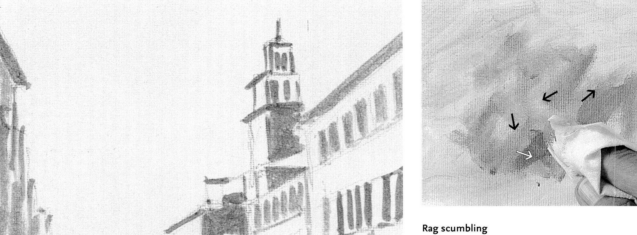

WHAT WENT WRONG
The underpainting was dry but the paint being scumbled over it was too thick.

Thin lines

Drawing a thin line with a brush is done in the same way with oil paint as with watercolour and acrylic. The paint needs to flow out of the bristles. Therefore the oil paint needs to be thinned with a medium: turpentine or Alkyd Flow medium.

Blending (brush)

Blending one colour into another when the paint is wet can be done with a brush. Work with a clean brush and use short brush strokes. Usually you will get the best results when you blend a lighter colour into a darker one, but this depends on the subject matter. Practise on oil sketching paper, using different brushes.

Blending (finger)

You can blend equally well using your finger. Simply work your finger gently into the colours to blend them. This is best done when the paint is not too thick.

Thin lines

Blending (brush)

Blending (finger)

WHAT WENT WRONG
The paint was not runny enough. Add turpentine or Alkyd Flow medium.

WHAT WENT WRONG
The wet paint was too thick to blend. It is much easier to blend with thinner paint.

WHAT WENT WRONG
The paint did not blend in successfully. If you are concerned about getting your fingers messy, go back to using a brush!

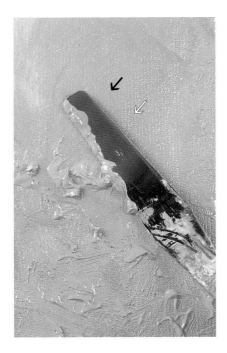

Scraping off

Scratching out

WHAT WENT WRONG
There was not enough paint
to scratch off. Try using a rag.

WHAT WENT WRONG
The paint was too thick to get
a clean edge.

Using a palette knife

A palette knife is used for mixing large
quantities of paint on the palette (I prefer to
mix with my brush), for cleaning paint off the
palette, and for scraping paint off the canvas
if the paint is too thick or if you want to repaint
a certain part of the work.

Scraping off

You can wipe off unwanted wet paint with your
finger, a rag or a palette knife. Although your
finger or rag may be able to cope with a small
area, a substantial area with thick paint will
need a palette knife. This will take the paint off
down to the canvas.

Scratching out

A palette knife and the wooden end
of a brush can be used to scratch thin lines
out of the paint.

Using a mahl stick

To work over wet paint, use a mahl stick. This
is a long stick with a pad at one end. Rest the
padded end on the edge of the canvas, support
the other end with your hand, and use the stick
as a rest for your brush hand.

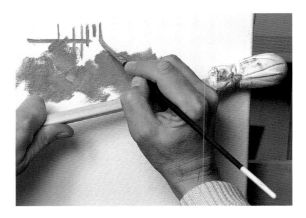

Using a mahl stick

BASIC KIT FOR OIL

Below is a list of materials you will need to get started with oil painting. Keep it simple to start with: the more kit you have, the more you have to master.

- Tubes of paint (colours on page 50).
- Flat brushes: Daler-Rowney Bristlewhite Series B48 Nos 2, 4 and 6.
- Round brush: Dalon D77 No.6.
- Rigger brush: Dalon D99 No.2.
- Palette, plastic or wood.
- Palette knife with a 7.5 cm (3 in) blade.
- Low-odour thinners.
- Alkyd Flow medium.
- Double dipper to hold each of the above.
- Mahl stick for steadying your brush.
- Jam jar to hold turpentine for washing out brushes.
- Canvas board, canvas paper or canvas.
- Pencil and plastic eraser.
- Rag for cleaning your brushes.
- Portable or table easel. You can rest the canvas on the back of a kitchen chair, or buy an oil-carrying box where the painting fits into the lid. This can be used on a table or on your knees when you are sitting down working outdoors.

ACRYLIC MATERIALS

Acrylics are a very versatile medium. They can be used like oils, but unlike oils they dry quickly. Watercolour techniques can also be used successfully with acrylics, but acrylics have their own unique character.

Choosing and using different surfaces

There are many surfaces onto which you can paint acrylics. My daughter painted a design on a pair of jeans with acrylics many years ago, and the design never washed off. I have painted on unprimed wood and pebbles from the beach. We have painted murals on the walls of our family homes with acrylic colours.

Acrylics are very versatile. The accepted 'normal' grounds are almost all those that you can use for oil and watercolour painting, with a few variations. Opposite are photographs of some of the surfaces on which I paint acrylics.

I have applied some paint and pencil marks to show the grain of the surface.

All oil ready-primed canvases must be primed with acrylic primer. There is a paper specially made for acrylic painting; it has a good painting surface and can be bought in pads. Bockingford watercolour paper, Waterford watercolour paper and cartridge paper can be painted on with acrylics without priming.

A transparent watercolour technique can be used for painting acrylics, or after washes have been applied the painting can be continued using the paint thick and opaque. An acrylic wash soaks into the unprimed paper more than a watercolour wash, but when you apply more paint as you work, the paint is easier to spread. I like this way of working. Below is one of my paintings done this way. I have even worked on brown wrapping paper (not primed) with good results.

Enjoying the Last Light
acrylic on Bockingford
410 gsm (200 lb) Not
(not primed)
35 x 48 cm (14 x 19 in)

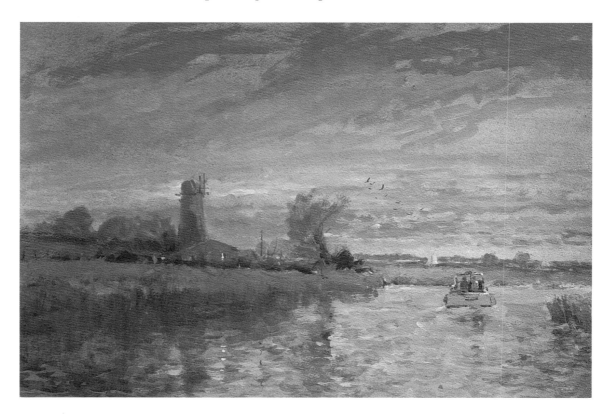

OPPOSITE:
These acrylic surfaces are reproduced actual size. The pencil I used was a 2B.

cartridge 150 gsm (70 lb) acrylic primed

canvas acrylic primed

brown wrapping paper

MDF acrylic primed

Bockingford 410 gsm (200 lb) Not

Cryla sketching paper

Choosing and using colours

As in all media, acrylic colours can be mixed from the three primaries (red, yellow and blue). On the right are the acrylic colours I work with. These come in tubes, like oil paints.

With acrylic colours there are two distinct ways of mixing them. Because acrylic can be worked transparently or opaquely, colours can be mixed in a similar way to watercolour or oil. I have shown this on the opposite page. This means that you can use the colour charts shown on pages 39 (watercolour) and 51 (oil) to practise colour mixing.

Whichever way you are working, because the paints dry quickly you need a 'stay-wet' palette on which to squeeze your paints, which will keep them wet for working. You can also buy slow-drying gel medium to mix into the colours on the palette as you work. The paint will then take a little longer to dry on the canvas. I only use this when I am painting a large area in one sitting. With experience you will get used to the paint drying quickly on the canvas.

 Crimson

 Cadmium Yellow

 Ultramarine

Primary colours

 Cadmium Red

 Raw Sienna

 Coeruleum Blue

Another set of primary colours

 Leaf Green

 Raw Umber

 Burnt Umber

Ready-mixed colours

Titanium White

The System 3 colours I use for most of my acrylic painting.

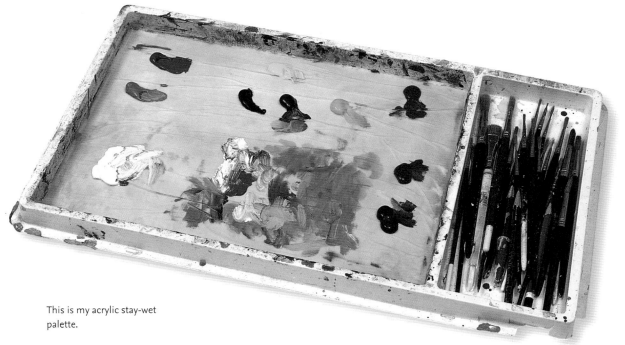

This is my acrylic stay-wet palette.

**Watercolour technique:
mixing transparently**

Crimson

Cadmium Yellow

Ultramarine

Crimson + Cadmium Yellow

Cadmium Yellow + Ultramarine

+ water

+ water

**Oil technique:
mixing opaquely**

Crimson

Cadmium Yellow

Ultramarine

Crimson + Cadmium Yellow

Cadmium Yellow + Ultramarine

+ Titanium White

+ Titanium White

Choosing and using brushes

You can use the same brushes for acrylic painting as you can for oil or watercolour painting. There are some excellent synthetic brushes specially made for acrylic painting, such as Daler-Rowney's Cryla range. I use these along with the oil and watercolour brushes already discussed (pages 40 and 52).

(pages 40 and 52)

Caring for your brushes: There is one important point to remember when painting with acrylics. Because acrylic paint dries quickly, if you leave a brush for 10 to 15 minutes, the paint may go hard and you could ruin your brush. If you wash your brush out thoroughly each time you change to another brush there would be no problem, but this is not always practical when painting. There are also the times the telephone rings, or someone calls to see you, you put the brush down and when you come back the brush is ruined.

To avoid this happening I keep my brushes in water in a tray continuously, 24 hours a day, and when I am painting a picture, I simply put each brush back into the tray as I finish with it (see the tray in the photograph on p.65). When I take my brush out again (it may be only minutes later), I wipe it on some rag to remove the excess water and continue painting. For over 40 years I have never had a brush go hard, and have always enjoyed painting with acrylics.

Never throw a brush away as it wears out; you will always find a use for it. Look at the photo below left. This brush has worked hard for many years, and lived in water all its life (it started as a flat synthetic bristle brush). I use it for dry brush work, painting rough areas of landscape foreground and many other areas of a painting.

Use your acrylics to practise the brush strokes you have been shown for watercolour and oil.

(see the tray in the photograph on p.65).

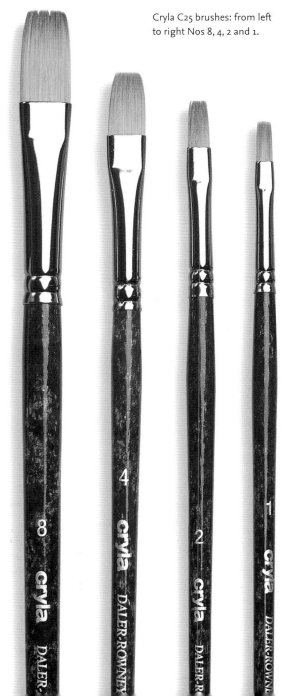

Cryla C25 brushes: from left to right Nos 8, 4, 2 and 1.

ALWYN'S TIP

Keep your acrylic brushes in water, except sable brushes (e.g. No.6 round).

This is one of my favourite 'worn' brushes. It has lived in water for many years. It started as a flat brush.

ACRYLIC TECHNIQUES

As I said earlier, some of the techniques used for watercolour and oil painting can be used for acrylic painting. However, there are some differences because of the medium. Daler-Rowney's Cryla Artists' Heavy Body acrylic colour, which has a thick buttery consistency, is ideal for thick impasto work. System 3 acrylic colour is more 'runny' and spreads more easily, and I use this paint for 80 per cent of my acrylic painting. The two are intermixable when you are working.

Using acrylics to paint a wash is done in the same way as watercolour but acrylics react differently on different grounds. Experiment, but keep to one painting surface that suits your way of working. By all means work on any surface you like once you feel confident.

To get even more impasto on the canvas, there is a medium you can add called texture paste. This thick paste can be mixed with paint and worked on the canvas. I sometimes use it for foreground areas such as muddy cart tracks. But use it carefully, don't go overboard and work it all over the painting. Experience will help you to learn when this effect works best.

Cryla Artists' Heavy Body acrylic colour

System 3

Texture paste mixed with colour

You can use the technique of scumbling with acrylic. Unlike oil paint, acrylic dries quickly and scumbling can be worked within minutes of applying the underpainting.

Acrylic paintings can be varnished with Cryla varnish, matt or gloss.

Here texture paste has been added to the paint to give the impression of muddy cart tracks.

Thin lines

Painting thin lines in acrylic is as easy as it is in watercolour or oil, if the paint is thin enough. Use water to thin your colour to the right consistency. It is almost impossible to paint a thin line with thick paint straight from the tube. This may sound obvious, but I have seen it tried on occasion by beginners.

Dry brush

This technique is the same as in oil and watercolour. It is used throughout a painting and can be created either by design or by a brush running out of paint in a passage of the painting. This can often result in a 'happy accident' (your paint or brush creating a great surprise effect).

Delicate scumbling

This is the same as scumbling, but with less paint on the brush and with the paint applied more evenly and carefully over the already painted image. This gives a very good impression of mist.

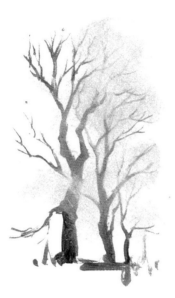

Delicate scumbling

Thin lines

Dry brush

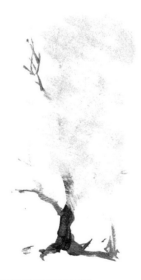

WHAT WENT WRONG
Paint too thick – use more water to thin it.

WHAT WENT WRONG
Too much paint in the brush, so it does not hit and miss.

WHAT WENT WRONG
Too much paint obliterated the underpainting (the tree).

BASIC KIT FOR ACRYLIC

These materials are all you need to get started with acrylics. Naturally you can add to these, and I am sure you will, but if you keep it simple at the start the learning process will be much easier than if you try everything that the art supply shop has to offer.

- Tubes of paint (colours on page 60).
- Flat brushes: either Bristlewhite Series B48, as I use for oils, or Cryla series C25 Nos 8, 4, 2 and 1.
- Round brush: Dalon D77 No.6.
- Rigger brush: Dalon D99 No.2.
- Stay-wet palette.
- Cryla sketch pad 51 x 41 cm (20 x 16 in) or a painting surface of your own choice.
- 2B pencil.
- Plastic eraser.
- Rag.
- Water jar.
- Brush dish.

As you progress you may want to try out gel medium, which will slow the drying when you are painting large areas, texture paste for impasto work, and varnish.

3 The way forward

This chapter shows you how to choose a subject to paint, and will help you to decide between the different media of watercolour, oil and acrylic. There are exercises showing you how to make objects look three-dimensional, lessons in simple perspective, and tips on how to use colours to achieve perspective and distance in your painting. The chapter finishes with a section on good design and composition.

PREVIOUS PAGE:
Evening Light, Gorey Castle, Jersey
acrylic on canvas
41 x 51 cm (16 x 20 in)

Turn Around
watercolour on Bockingford
410 gsm (200 lb) Not
35 x 25 cm (14 x 10 in)

CHOOSE YOUR SUBJECT

In the early days of my painting career I didn't know which subject I should concentrate on. After all, it's not easy to choose; the subjects are limitless. But they can be broken down into main categories: landscapes, portraits, flowers, boats, still life, buildings, seascapes, animals and so on.

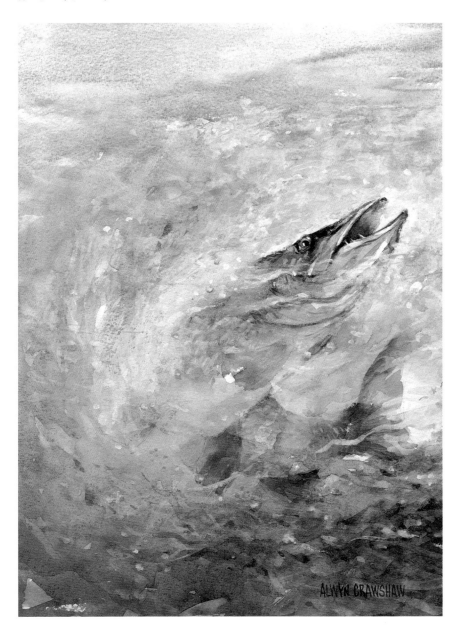

If we then take just one of these categories, say landscapes, this can also be broken down, for example into rivers, forests, moorland, mountains and meadows. Then each one can be taken further. Simply add atmosphere: sunny, windy, misty, rainy, sunrise, sunset; then add the four seasons: spring, summer, autumn, winter; and finally add to this the way you see things. This will give the painting your unique creative input, your 'signature'. For instance, you may prefer a close-up view or a distant view, a low horizon or a high one with little sky showing. It is obvious that I could break this down even further, but it illustrates how even if an artist painted just one subject for a lifetime, he or she should never be looking for something to paint.

Find your favourite

But how do you choose your subject? When I began to paint it took me nearly two years of working on different subjects before I realized that my subject was landscape. How? It was my favourite. You must choose your favourite subject. I have always loved the landscape in all its changing moods and seasons. Landscape was my natural subject matter. It's a pity I didn't realize it earlier; it would have saved two years of frustration! So if you love gardening and flowers, that could be your natural subject, or if you get excited about the sea and its surroundings, or you are fascinated by people's looks and expressions, then the sea or portraits could be your natural subject.

Having a natural subject that you love and get enthusiastic about will always give you something to paint, and more importantly, you will never have to think about what to paint. Over the years, many students have said to me that when they are at home practising they often have a block and don't know what to paint. I then explain about finding their natural

The One That Got Away
watercolour on Bockingford
410 gsm (200 lb) Not
35 x 48 cm (14 x 19 in)

subject, whatever it may be. If they haven't found it, they soon do, and it gets them started again. Another very good reason for painting your favourite subject is that you know the subject well because you enjoy it, and the more you know a subject the easier it is to paint, and the better the painting.

This doesn't mean that you should only paint your natural subject. On the contrary, you should always try different ones. Tackling a different subject can prevent you from becoming complacent and overconfident with your natural one. It will also stretch your painting imagination as well as your skills of observation.

Throughout the book you will see many different subjects I have painted, like the fish above. I have been a keen fisherman all my life, and a couple of years ago I wanted to paint something exciting and different. Eventually an obvious solution came to mind. I produced a series of paintings of freshwater fish. I thoroughly enjoyed painting these, and when my enthusiasm diminished, I went back to landscapes with a fresh and eager approach.

Your natural subject is a vehicle for learning. You like the subject, you know the subject, it's always there. Practise your painting using this, and let time and experience lead you naturally to try painting other exciting subjects.

CHOOSE YOUR MEDIUM

If you already paint, then you know which medium you prefer to work with. Let's call this your natural medium. If you are a beginner then you will need to choose just one to be your natural medium to work and practise with. In Chapter 2 I showed you what the three media can do and what basic equipment you need for each. This chapter will help you to decide which one you would like to work with.

Watercolour

Watercolour is often a favourite, especially with beginners. There are many reasons for this. Firstly, we have all been introduced to watercolour at an early age in school. Usually the paints were poster paints in jars or powder paints, which, like watercolour, you use water to mix. Secondly, paper is the surface (ground) on which you work, and we are all familiar with paper. Thirdly, there is no smell to find its way into the kitchen or living room at home! Finally, you don't need an easel to work on. You can work with the paper (on a board) on

A Jersey Beach
watercolour on cartridge paper
20 x 30 cm (8 x 11¾ in)

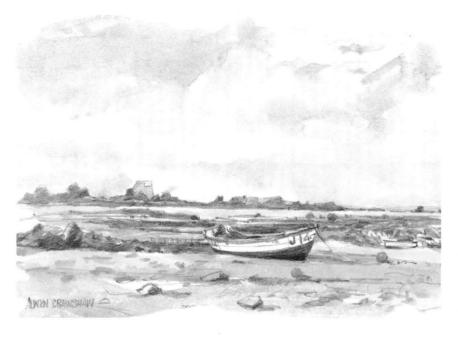

your knees. The materials are also easy to carry when you want to paint outdoors.

Oil

Oil paint has the disadvantage of not being as practical for the beginner as watercolour. You need an easel or some form of support to work on. There is always an 'oil' smell, although using low-odour thinners in place of turpentine cuts down the smell tremendously. Oil paint takes a long time to dry, but I add Alkyd medium, which helps the paint to dry much more quickly. Finally, you will have more equipment to carry for painting outdoors. But if you accept all this, the pleasure of oil painting is immense. You can paint over areas you are not happy with, or wipe them off and start again. You can 'feel' the paint as you put it on the canvas and blend the colours together, and you can paint very small or very large pictures.

Acrylic

Acrylic paint has some of the properties of watercolour and some of oil. It also has its own. It doesn't smell. You use water to mix the paint. You can use it in the same way as watercolour, working the colours transparently, but once it dries you can't move the paint again, as it is impervious to water. You can paint over it again and again and it will not mix with the underpainted layers of paint. Using less water, the paint becomes opaque and you can paint using some of the oil techniques. Unlike oil paints, however, acrylic dries very quickly. Using oil techniques acrylic paintings will dry in minutes, where oil would take days.

Which is right for you?

When choosing a medium it is important to take into account your character. For instance, someone who is flamboyant, outspoken and larger than life will not be happy sitting down

painting small, delicate watercolours! But I am sure he or she would feel at home painting a large oil painting, standing at an easel, holding a large palette thick with paint and wielding a No.12 hog's hair brush at the canvas.

If you are a beginner, I recommend starting with watercolour. It is the most practical and user-friendly for practising and learning the basics of painting.

Some subjects, especially landscapes, work better in some media than others. When I am

outdoors, I see scenes as a watercolour or oil or acrylic painting. If you see something that you would love to paint, but you don't think it would work well in your natural medium, then I would recommend that you don't try to paint it. You may want to try it as a challenge, and it is a way of gaining more experience but, although you may learn from the experience, you must be prepared for the painting not to be your best. Eventually you will get to know which subjects will work well in your medium.

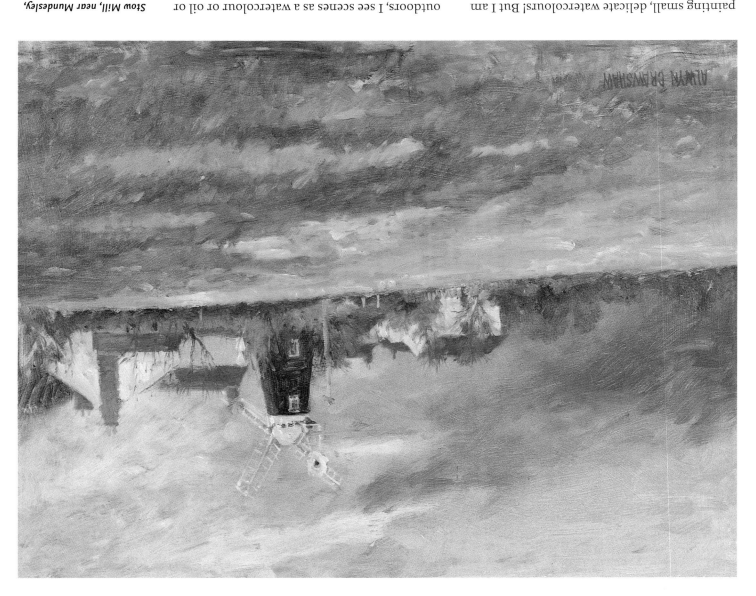

Stow Mill, near Mundesley, Norfolk
oil on primed MDF
30 x 41 cm (12 x 16 in)
When I saw this, I knew it was a subject for an oil painting. I felt I could get movement into the stormy sky and the foreground field.

THE FIRST STEPS

There is a natural sequence to painting
a picture, whatever medium is chosen. In its
simplest form it starts with the design; then
comes the drawing stage, which includes
linear perspective; then applying colour, using
aerial perspective; evaluating tonal values; and
using soft and hard edges (lost and found),
which help to make the objects in your
painting more real.

Don't worry if this sounds complicated – it
isn't. We will take it stage by stage. When most
people are first shown all the operations that
have to be done to drive a car, they feel it will be
impossible to grasp them all. But they do it and
it becomes second nature to them. This is
because they are taken through the procedures
step by step. This is the way we will go through
this book. Because some of the lessons and
techniques to be learned overlap with each other,
or are used in different ways, you will find some
are repeated, in different chapters, throughout

the book. Always remember your goal – to reach
the top of the mountain – but remember that
to reach it, you must practise.

Drawing

In Chapter 2 I showed you how to use a pencil.
Drawing is the planning stage of a painting.
I can just see you reading the last sentence and
feel your dismay! 'I want to paint, not draw',
I can hear you say. Well, paintings can be done
without drawing first. But applying paint is still
drawing shapes. You will need to gain
experience first if you want to paint without
'drawing'.

Drawing lays the foundation on which your
work will be developed, even if it's only some
basic but important shapes that you draw.
Naturally, as a painting develops it can change
from the original concept, but the drawing
stage gets the painting started.

If drawing isn't one of your natural talents,
don't let this interfere with your painting

*Start with simple
subjects – an apple
or a banana. Don't
attempt a complicated
scene straightaway.*

progress. You will find that the more you do, the better and easier it becomes. Practise drawing simple things first; an apple, a banana, objects you can do indoors, but don't try drawing a harbour scene full of boats until you have gained some experience! A painting of one simple object can be just as powerful as a complicated painting. A poor drawing can be helped with good painting, and a good drawing can be spoiled by poor painting.

Let me analyse the oil painting below. When I first looked at the scene I thought that I was going to have the windmill as the focal point (see page 83), then the yacht sailed into view and to me it made a better focal point because of its strong image. So I put it in. If you cover the yacht with your finger, your eye is led to the windmill.

When I was drawing the basic picture I included just the important constructing lines. The curves of the clouds take you from the top of the painting to the horizon – this gives the impression of distance, helped by the horizontal fields getting narrower to the horizon and the foreground path leading you into the scene

I drew the important lines on cartridge paper (left) to show you the first steps in painting the oil painting below.

(linear perspective, see page 74). I used stronger and warmer colours in the foreground, becoming cooler and eventually 'blue' for the distant trees to help give a sense of distance (aerial perspective, see page 76). For the same reason, the sky is much lighter than the ground, and the distant fields and trees are paler than the foreground ones (tonal values, see page 78).

The sails on the large yacht have hard edges, those on the one behind have soft edges. The cows and the clouds in the sky are made up of hard and soft edges (see page 80).

Summer, the Norfolk Broads
oil on canvas
30 x 41 cm (12 x 16 in)

Perspective

Don't turn over the page, perspective is important! Many students fight shy of it, simply because it seems more like geometry than painting. However, by learning just a few fundamental laws of perspective you will be surprised how easy your drawing and painting will become.

ALWYN'S TIP

Don't be frightened to learn about perspective. The basic rules are very simple.

Eye level: Let's begin with the eye level (**EL**). If you look out to sea, the horizon will always be at your eye level, even when you climb a cliff or lie flat on the beach. Check this by holding a pencil horizontally at arm's length and looking past the pencil to the horizon: the pencil will be aligned with it.

If you are indoors there is no horizon, but you still have an eye level. Hold your pencil at arm's length and look past it to the opposite wall: your eye level is at the spot you are looking at.

Vanishing point: If two parallel lines were marked out on the ground and extended to the horizon, they would converge at what is called the vanishing point (**VP**). This is why railway lines appear to approach each other and finally meet in the distance – they have met at the vanishing point.

In **A** (opposite) I drew a flat square on paper. Then I drew a line above to represent the eye level. Above the square and to the left of the eye level I made a mark, the vanishing point. With a ruler I drew a line from each of the four corners of the square, all converging at the vanishing point. This gave me the two sides, the bottom and the top of a box. For the other end of the box, I drew a square parallel with the front of the box and kept it within the vanishing point guidelines. The result is a transparent box in perspective. We are looking down on the box because the eye level is above it. In **B** we are looking up at the box, because the eye level is below it.

I have applied the same principles in the drawing of a row of houses with windows and doors.

A simple reminder

Circles drawn in perspective become ellipses. Try this simple experiment. Hold a coin flat in front of your eyes. All you will see is the edge of the coin, a straight line (your eye level). Now move the coin up (holding it flat all the time); the coin is now above your eye level and you will see the underneath of it; the shape is an ellipse (a circle in perspective). Now move the coin down past your eye level and you will see the top of it. You see the underneath of anything that is above your eye level and the top of anything below it.

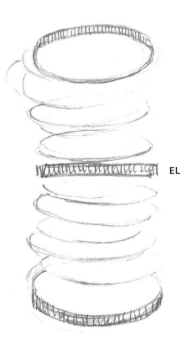

EL

Hold a coin horizontal in front of your eyes. This is your eye level (EL). If you move the coin up you see the underside, if you move it down you see the top of it. You will see underneath anything that is above your eye level and the top of anything below. Use the coin to remind you.

EL VP

Railway lines appear
to meet at the horizon.

VP EL

Drawing a three-
dimensional box
viewed from
above (**A**) and
below (**B**).

A

Leave out the guidelines
and you have a solid box.

EL

B

Use the same principles you
applied when drawing the
three-dimensional box to
copy this bird's-eye view of
a street of houses.

EL VP

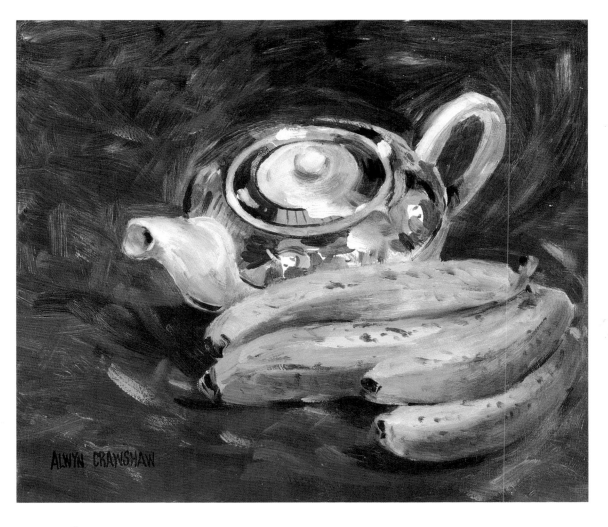

ALWYN'S TIP

*Cool colours (blues)
recede into the distance.
Warm colours (reds)
come forward.*

Using colour

In addition to your brush strokes and
painting technique, your colour sense helps to
give your picture its personal signature. Some
artists paint in a high key (bright colours) and
others in a low key (less colourful). You will
also find that artists have a tendency to paint
either with warm colours or cool colours.
For years my paintings had a 'cool' look; I have
always loved misty, wintry atmospheres and
the cool and subtle colours they create,
so perhaps the love of these colours has led
me from the beginning down this colour
path. Perhaps because of this I am never as

happy working in a high key with lots of
strong colours. In latter years I have made
a conscious effort to warm up my paintings,
as more colourful and warmer paintings
appear to have more appeal – or is this
just fashion?

Whatever your natural colour sense or
preference, nature has given us a means of
creating depth and distance in a painting by
using colour. This is called aerial perspective.
The golden rule to remember is that cool or
cold colours (blues) recede into the distance,
while warm colours (reds) advance. Colours
are also stronger in the foreground and paler

distant trees smaller

cold colours (blues) recede

distant
fields paler

more detail in
foreground

perspective
lines

warm colours
advance

in the distance. If we add perspective (p. 74) to aerial perspective, we have more ways of creating depth and distance in our paintings: objects in the distance get smaller with less detail, and you see more detail in objects close to you. Directional lines drawn in perspective also help to show direction and distance.

Sydney Harbour
watercolour on
cartridge paper
20 x 28 cm (8 x 11 in)
My 'natural' colours are cool;
low key.

Tonal values

On a surface that is flat and two-dimensional, we have to create a painting where objects look solid and three-dimensional, using what are called tonal values. A painting done with a perfect drawing and perfect colouring, but with tonal values not used correctly, will look flat and uninteresting.

Tonal values are simply the brightness and darkness of objects within the painting which help to give shape and form to them. When we look at a scene or a still life subject, we can see where the dark and light areas are, but why are they there? The answer is simple, and it can be found in one of the first questions you must ask yourself when starting a painting. 'Which direction is the light coming from?'

When an object is hit by light, its opposite side is in shadow (darker). Look at the shape above right. There is no substance to it, it is flat, it could be anything. Now look at the middle picture. Here I have 'put the light on'; shadows have been cast and the flat shape has become an empty box.

Light against dark: Another very important element that makes the box appear three-dimensional is 'light against dark' or 'dark against light'. If the shadow I added was the same tone as the flat shape, you would not be able to see it. Light against dark or two areas of paint (no matter how light or how dark) where one is lighter or darker than the other will make an object look three-dimensional and show its shape like the cube on the right. In general, a strong contrast between light and dark areas will give the illusion of strong sunlight.

The examples on the opposite page will help you to understand the basic ways to make your paintings three-dimensional. Try copying them.

ALWYN'S TIP

Light against dark or dark against light makes objects three-dimensional.

light off

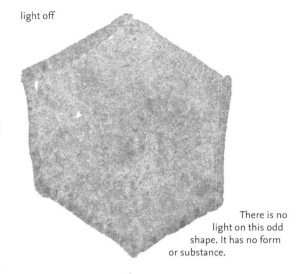

There is no light on this odd shape. It has no form or substance.

light on ↘

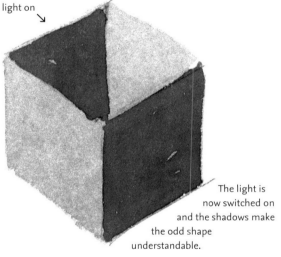

The light is now switched on and the shadows make the odd shape understandable.

soft light ↘

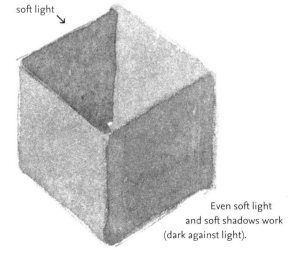

Even soft light and soft shadows work (dark against light).

Add just one dark shadow to the shape far left and it becomes a folded card.

Only two darker tones make this odd shape into two men in a boat – dark against light.

Adding tone to the first shape makes a hollow cylinder.

Using just one tone makes a silhouette skyline.

Soft and hard edges

Soft and hard edges on objects in paintings help to give them three dimensions, as well as helping to merge objects into each other or to keep them separated.

When you are first looking at your subject, one of the most important principles is to simplify what you see. Nature is full of detail, and you can't paint every blade of grass. You can simplify what you see if you learn how to squint. This is one of the most important skills. Half-close your eyes until you see your subject without detail. You will see only shapes. Your detailed subject has turned into a series of simple shapes. Another important thing has happened; you can now see most of the tones as only the lightest and darkest. The middle tones have disappeared. This not only helps to simplify the subject, but also gives you an insight into the tonal values of the scene (dark against light). Try squinting at a scene now. You may find it difficult at first, so keep practising.

Lost and found: When you look at your subject, some shapes will stand out sharply against the adjoining object (hard edges), and others merge into the next object (soft edges). This is called lost and found. An object can lose its shape in one place (lost edge) and retain it elsewhere (found edge). When you squint and see edges, hard or soft, you must paint them like that. Do not paint what you know, paint what you see!

Pencil sketch with soft and hard edges.

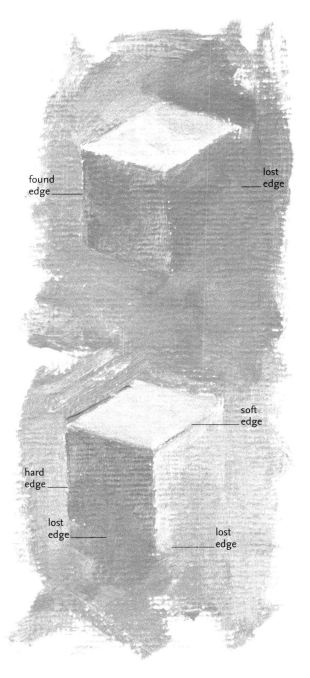

These two boxes show how you can lose an edge on an object, have a hard edge and a soft edge, but still visually retain the object's shape and form.

Hickling Regatta
oil on canvas
51 x 61 cm (20 x 24 in)
Like most paintings, this
has many lost and found,
hard and soft edges. Can
you spot them?

DESIGN AND COMPOSITION

What is design and composition? It is the positioning of objects on paper in a way that enables you to tell a story visually to the onlooker. But design is so much a matter of personal observation that it is difficult to say what is good or bad. We don't always know, when we like a picture, how much the design and composition influences us. It may be the subject, the colours or the artist's painting techniques that attract us.

In recent years, design has been changing, contrary to many old established 'rules'. This is true of many things and is the way of evolution or fashion. For instance, extreme close-ups of people on television, perhaps showing only their mouth as they talk, are now commonplace, whereas 20 years ago these would have been considered bad composition. The same has happened to painting – almost anything goes. This is not a bad change; an unusual design can give a painting power and visual energy. It also gives the artist the opportunity to show his or her imaginative and creative ability.

Basic rules

Despite the fact that people are trying out new ways of working, when you are starting out

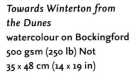

Towards Winterton from the Dunes
watercolour on Bockingford
500 gsm (250 lb) Not
35 x 48 cm (14 x 19 in)

there are some basic rules that will help you. Perhaps the most important one is that your painting will need a centre of interest or focal point. This is the most important part of your painting; it is where you want the onlooker to be led to, and it must be easy to see. Your painting will need to be designed around this.

At art school I was taught a very old system that has been the yardstick for all my paintings ever since. It is a good rule for you to remember. Imagine your paper is divided into thirds, vertically and horizontally. The points at which the divisions cross, **A**, **B**, **C** and **D**, are called the focal points. If your centre of interest is positioned on or around one of these focal points, then you should have a good design.

Another tip, when you are composing a landscape or seascape, is always to have the horizon above or below the centre of the paper, never in the middle. Also, when working outdoors, you will find that nature's lines – hedgerows, rivers, roads and so on – if observed carefully, will help to bring your picture together and form a natural design.

In the watercolour painting opposite I like the powerful design of the picture, which I created by the strong cloud formation. This is an example of nature's lines leading your eye to the centre of interest.

ALWYN'S TIP

When painting a seascape, have your horizon below or above the centre of your paper, not running through the middle.

A Fisherman's Tale
watercolour on Bockingford 410 gsm (200 lb) Not 23 x 16 cm (9 x 6¼ in)

The four focal points for putting in a centre of interest.

Each centre of interest is at a focal point.

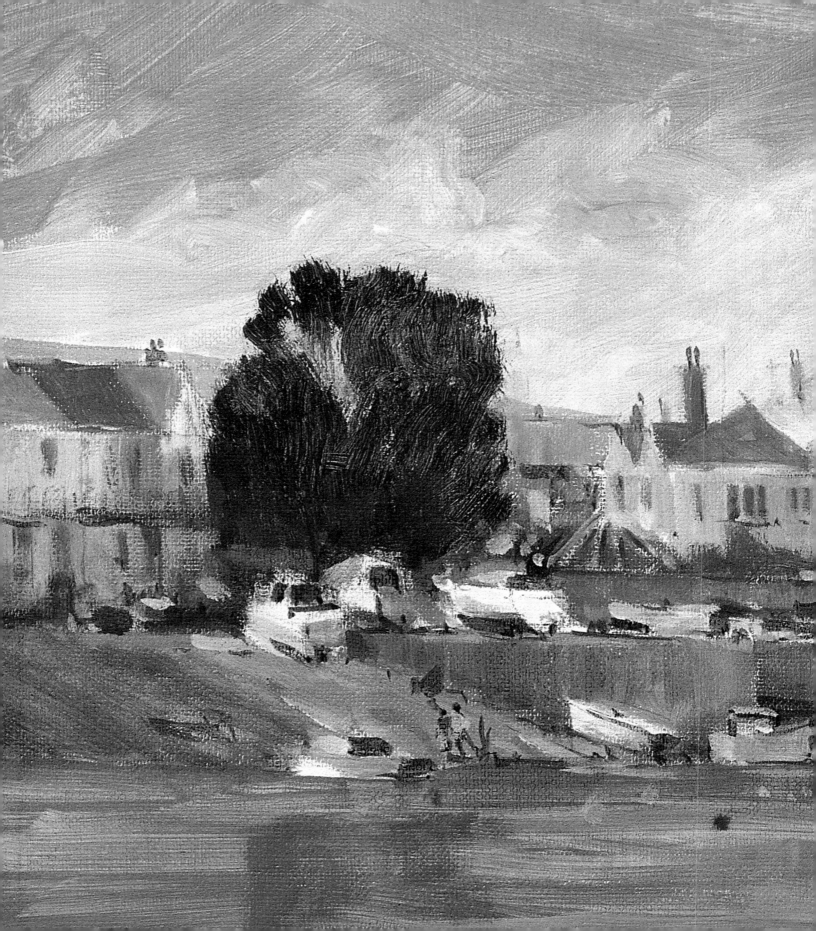

4 Working at home

A great deal of painting is done at home – it is far easier to sit in comfort indoors when you are practising. This chapter provides you with exercises you can practise at home: for example, learning to paint using only the three primary colours of red, yellow and blue, which will teach you how to mix other colours. It also gives you guidelines on how to paint successfully from photographs, which will always provide you with a subject to paint from when you are indoors.

Late Autumn Landscape
watercolour on
cartridge paper
20 x 28 cm (8 x 11 in)
I painted this using only
three primary colours.

THREE-COLOUR EXERCISES

The three-colour exercise is the perfect way to learn how to mix colours. As I have already mentioned, you can mix all the colours you need from just the three primary colours: red, yellow and blue, and there are different reds, yellows and blues to help produce the different colours you need. Using only three colours or six (two of each of the primaries) will help you to learn about colours. If, for instance, you wanted a brown and you were using ready-mixed colours, you could choose one, but it might be too 'warm', too 'red' or just the wrong brown for your painting. It would be difficult to know how to make the brown you wanted, simply because you have not learned how to mix a brown. When you mix your colours from the primary colours you get an all-over harmony of colour on your paintings, and your colour mixing is more subtle.

Remember, you must start mixing using the predominant colour. It is almost impossible to mix nature's colours perfectly, so don't let this worry you. Mix the colours as close as you can – remember you are creating a painting, not a photographic copy. Have a go at this exercise.

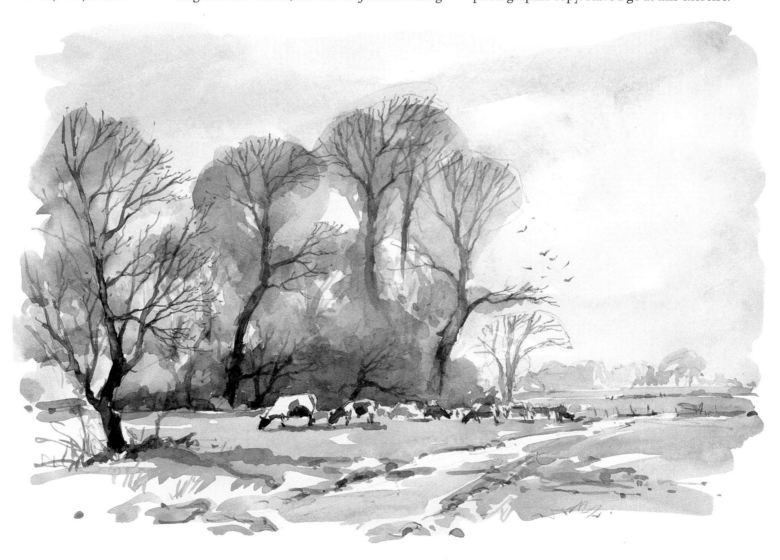

Three-colour exercise *in watercolour*

Try this exercise using only three primary colours. I used French Ultramarine, Alizarin Crimson and Yellow Ochre.

Stage 1
Draw the scene with your 2B pencil. Using your No.10 round brush, paint the sky. Start with French Ultramarine and a little Alizarin Crimson, then work Yellow Ochre and a little Alizarin Crimson down to the horizon. Using the same three colours, paint in the distant trees using a No.6 round brush.

Stage 2
Using the same brush, paint in the distant and ploughed fields, then the two large trees. Use French Ultramarine as the predominant colour in your mix. Paint the right-hand trees with your rigger brush, using Alizarin Crimson as the predominant colour.

Finished painting
With your No.6 brush paint the 'feathery' branches on the trees. Paint the two hedgerows, the grass verges, then the path. Notice where I left small areas of unpainted paper. The brush strokes were mainly painted in the direction the objects were going or growing, helping to give form, shape and life to the watercolour. Finally, put the windows in the cottage. This scene is a real place, and nature has made the design.

◀ **Stage 1**

◀ **Stage 2**

▼ *The Country Lane*
**watercolour on
cartridge paper
15 x 25 cm (6 x 10 in)**

WORKING FROM PHOTOGRAPHS

I believe that now we are in the twenty-first century, the myth that artists should not paint from photographs should be put to rest forever. These days you can use a mobile phone to take a photograph, then send it to someone, even in another country, 'type' some words of description with it and talk to the recipient if you want, all in a matter of seconds. Why, then, should we stay in the past and not use new technology to help us when we are doing our painting?

After all, the old masters didn't have their paints in tubes. Artists must have jumped for joy when they first had these. When John Constable and Turner travelled hundreds of miles to paint, wouldn't they have been the first to recommend cars and trains? And I'm sure I know what they would have said about the camera – 'Aren't you lucky' – and the same can be said for the electric light bulb.

We are lucky to have this technology, so do use anything that helps you, especially a camera.

The photo from which I worked when painting the picture opposite.

ALWYN'S TIP

Use the camera as an aid – not as the master to be obeyed!

First learn the rules

• My most important rule is that painting from a photograph is not a shortcut to learning to draw or paint.

• Take your own photographs. This enables you to absorb the atmosphere and circumstances of the moment, before and after taking the shot, giving you more information to work from back at home.

• If practical, make a simple small pencil sketch, featuring the main elements of the scene, when you take your photograph. Compare this sketch with the photograph to see the difference between what the camera saw and what you saw. When we look at something our eyes see the main object, and the surrounding

image is out of focus. But in general the camera sees everything and puts it all in focus.

• A photograph always 'flattens' the middle distance of a scene. Remember this. Check it against your sketch of the same scene.

• Colour can be unreliable in a photograph. Experience and working outdoors will help you to overcome this difficulty. But for a pencil sketch of, for instance, a harbour, a photograph will help you to remember the colours of boats, buildings etc. once you are back at home.

• When you take a photograph, don't just take one, take several around the scene. You will find you always need to know what happens a bit

further to the left or the right of the photograph you are working from.

- A photograph is a very reliable source for detail. If you do a watercolour sketch and want to produce a larger painting from it at home, a photograph is invaluable for detail, if that is what you want.

- Don't become a slave to a camera; remember you are an artist. Use the photograph as an aid, a guide, reference or inspiration, but remember to put your own 'painting style' into your work. Don't 'copy' the photograph.

- Photographs are great for the winter months when you have to work indoors – you always have a subject to work from.

- Finally, don't let the camera take your natural drawing and painting skills away. Copying from a photograph will teach you how to draw from a two-dimensional object. Copying from nature teaches you how to create a drawing in two dimensions from a three-dimensional object (real life) and this is a basic requirement for an artist. The camera has an important role to play. Use it in its correct place and you will have a painting friend for life.

Café at Domm, Dordogne, France
watercolour on Bockingford 410 gsm (200 lb) Not 48 x 35 cm (19 x 14 in)
Before I could take the photograph opposite, the sun went in and the shadows disappeared. Therefore I used my memory and artist's licence to add the shadows to my painting. They are important because they help to give depth to the painting.

The photo I used for these paintings.

PHOTOGRAPHS AS INSPIRATION

I took this photo of Horning village on the Norfolk Broads from our boat. I have been past this scene on many occasions. I decided to do a small oil painting from the photo.

As the photo is very 'picture postcard' looking, with blue sky and blue water, I decided to give my painting a different atmosphere. I chose a cloudy day with a strong breeze creating small breaking waves on the water. This type of day is not uncommon on the Norfolk Broads. I didn't paint the yacht as white and bright as it appears in the photo, because this would have stopped your eye from travelling through the picture.

I also painted the scene in watercolour. Because the watercolour and the oil are both of the same scene, they provide a good example of the differences between the two media. The most obvious difference is that the watercolour is more crisp and clear and brighter than the oil. This is partly due to the atmosphere. I painted the watercolour with a rain shower having just passed over, and visually everything becomes sharp and clear.

Notice how I left a passage of disturbed water (unpainted paper) behind the blue and white cruiser. This helps to lead your eye into the picture. You can also compare the details, which are reproduced here actual size.

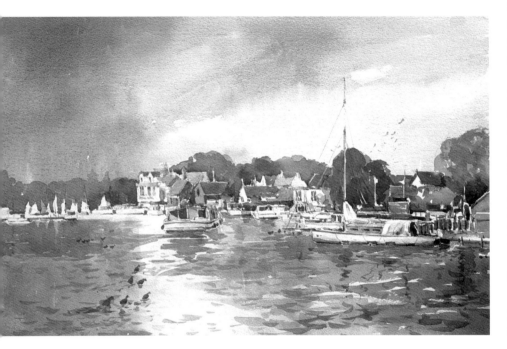

On the River Bure, Horning
watercolour on Bockingford
410 gsm (200 lb) Not
35 x 48 cm (14 x 19 in)

Detail from the watercolour above, reproduced actual size.

Horning, Norfolk
oil on primed MDF
25 x 30 cm (10 x 12 in)

Detail from the oil painting
above, reproduced actual size.

Dandelions *in acrylic*

I used the two photographs below as a starting point for this painting. They gave me the inspiration. You can see I didn't try to copy every blade of grass. I used the photos more for information, as you would a sketch. But the difference with photographs is that they provide you with as much detail as you would ever need for a painting.

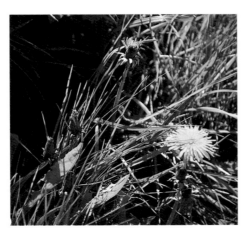

These are the two photographs I used as inspiration for my dandelion painting.

▲ **Stage 1**
Draw the simple shapes with your 2B pencil. Using your B48 No.4 brush and a wet mix of Titanium White, Leaf Green, Ultramarine, Crimson and Raw Umber, paint in the background. Now paint the dandelions with a mix of Titanium White, Cadmium Yellow and Cadmium Red, with your B48 No.2 brush.

▲ Stage 2

Using your B48 No.4 brush, paint the background darker on the left side, using the same background colours as before, but without white. Keep the paint watery. Now change to your No.6 round brush and paint in some grasses and leaves using the same colours. Try to do this in single brush strokes, watery for the dark ones, adding white and thicker paint for the light coloured ones. With your B48 No.4 brush and a 'dirty white', use the dry brush technique to suggest the dandelion clock.

▲ Finished painting

Continue painting the dandelion clock. Using white paint on your No.6 round brush, gently 'dab' the edges to show the shape, and paint the top of the stem. Paint the petals of the flowers using thicker paint. Start your brush strokes in the centre of the flower and work outwards. Now paint some more grasses and leaves. Because of the way the background grasses and leaves were painted, it will be impossible for you to follow mine exactly.

Dandelions
acrylic on primed
Bockingford 500 gsm
(250 lb) Rough
13 x 10 cm (5 x 4 in)

The beach *in oil*

When working from a photo of a real place, your painting has to be accurate enough for the scene to be recognizable. Here I couldn't have left out the large rock, as the place would no longer be identifiable, but I did omit the foreground greenery, as I felt it would not work in a painting. So follow the photograph, but paint your own interpretation of it.

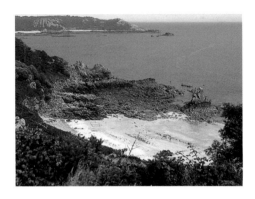

The photo of the beach that I used. Before I took the photo I also did the pencil sketch below from the same spot.

▲ Stage 1

Paint an acrylic wash of Raw Sienna and Crimson over the board. When this is dry, draw in the main structure with a turpsy mix of French Ultramarine and Crimson Alizarin, using your No.6 round brush. Use your B48 No.4 brush to paint in the dark areas of the rocks with Titanium White, French Ultramarine, Crimson Alizarin and Raw Umber.

Stage 2

Paint the sea with your B48 No.4 brush. Start at the top using Titanium White and French Ultramarine, add Cadmium Yellow, then nearer the beach use Titanium White, Coeruleum and Cadmium Green. Next add more white to the rock colours and paint the remainder of the rocks with the B48 No.2. With the same brush, start painting the beach using Titanium

White, Yellow Ochre, Cadmium Yellow and a little Crimson Alizarin. Paint the brush strokes following the curve of the beach.

▼ **Finished painting**

Continue with the beach, then paint in the large rock's reflection with thin paint, working light (sea colour) areas on each side. Put some more darks and lighter colours on the rocks and paint in some dark waves and white caps on the sea and beach. Now add the people with your rigger brush – use thick paint, this will help to make them more prominent.

The Beach
oil on canvas panel
23 x 30 cm (9 x 12 in)

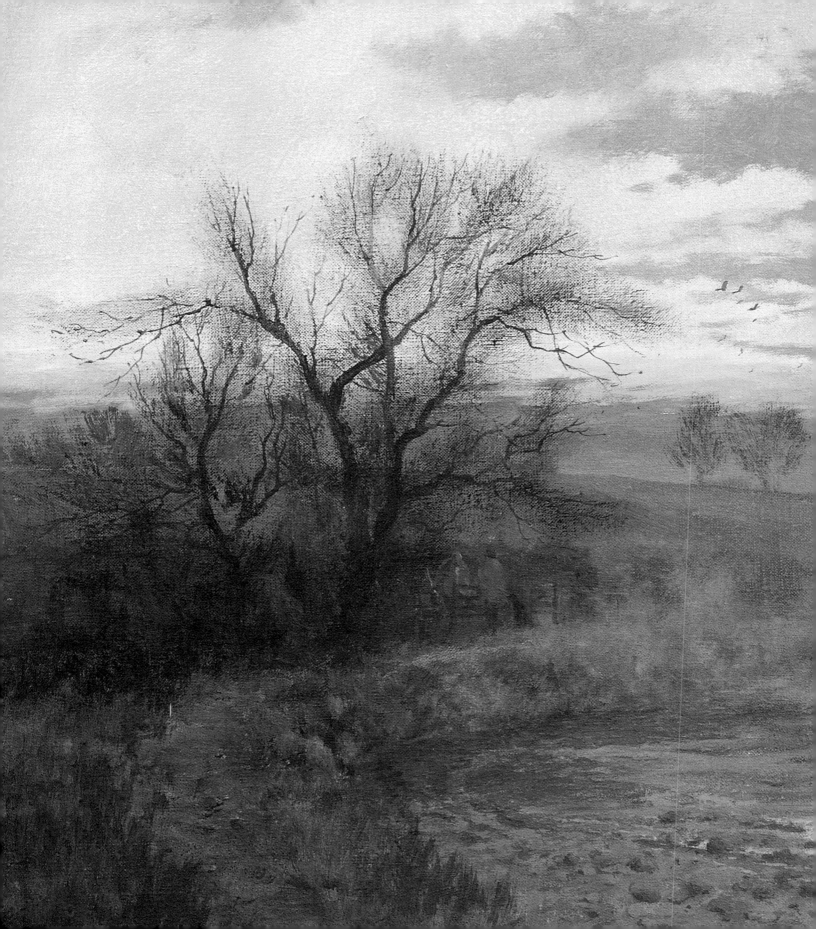

5 Working outdoors

Deciding what to paint is one of the most important decisions you will need to make when you are painting outdoors. This chapter makes recommendations to help you to decide. It covers sketching outdoors, with simple explanations of three different types of sketches and their practical use. It teaches you how to work from a sketch once you are back at home. Finally, it shows you the half-hour exercise, a way to practise working fast that will inspire you with confidence when you are painting outdoors.

BEFORE YOU BEGIN

One of the great assets of being an artist is that you can work outdoors or indoors, so there's no excuse for not practising on a rainy day! Painting outside is one of the most rewarding experiences for an artist. But for the beginner there are some simple things you will need to consider before you venture out.

Check your equipment

It may sound obvious to check that you have everything with you, but I have been caught out in the past. When June and I were in Australia we were taken up into the Blue Mountains for a day's painting. After drawing my first sketch I reached into my bag for my watercolours, and realized they were 60 miles away back at base. Fortunately help was at hand, and I was able to use June's (after she had finished her painting – I am a gentleman!).

A few years ago we were in Cornwall sketching and photographing harbours. At the end of a long day with many pencil sketches and photos in the bag, I found that the 36 transparencies had been taken without a film in the camera!

Feel confident

Many students are worried about passers-by stopping and talking to them. Don't worry. These people admire you. After all, you are sitting in the public eye and most of those people wish they had the courage to do the same. It doesn't matter how 'poor' you think your painting is; the onlooker believes that it is still to be finished – even if it is finished!

The Blue Mountains, Australia
watercolour on cartridge paper
28 x 41 cm (11 x 16 in)

PREVIOUS PAGE:
Evening Mist, River Otter, Devon
acrylic on canvas
40 x 61 cm (16 x 24 in)

You can always have a small sketchbook, say A5, and do some pencil sketches sitting behind a tree, a wall, or a boat, where you can't be seen, until you gain confidence. The best way is to go out with a painting friend and sit within talking distance of each other. This is a great confidence booster.

Choose your subject

Although there are unlimited subjects to paint when you are outdoors, it can be very frustrating trying to decide on one. From my experience, if a scene inspires you, stop and paint it. This sounds simple. But often we feel there could be a far better scene around the next corner. When you get there, it could be better around the next, and so on, and when you finally find a scene and are ready to start, it's time to go home. If you have time when your painting is finished, then by all means go round the next corner and find others: but the first scene that inspires you, paint it!

Some further tips

Work to a size of painting that can be finished in your timescale. Don't end the session with a half-finished painting; you may never go to that spot again. Also, never judge your painting, when you have finished it, outdoors. It will always look better at home.

When you are outdoors, objects move. A boat you are painting can sail away – a coach can park in your view – people can stand in front of you and block your view, and so on. There is no answer to this, except to use common sense and be prepared not to get too dejected if you have to abandon a painting halfway through – that is part of the experience of painting outdoors.

Don't carry too much

Finally, take only as little equipment with you as you need. Don't be one of those walking artist's

Shiraito Falls, Japan
watercolour on cartridge paper
30 x 20 cm (11½ x 8 in)

studios. I am sure you will have seen them staggering across fields and ditches carrying watercolour, oil and pastel equipment, shoulders bent with the weight of an easel, packed lunch and folding seat. June and I have met them on our painting courses, and by the time they have found a spot to paint from and decided what medium to use, it's time to go home! By the end of the course we have enlightened them in more ways than one.

Remember, don't just look – observe. You can't paint what you don't see!

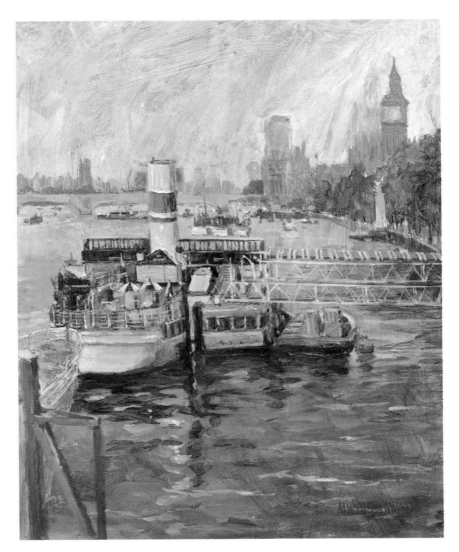

Big Ben
oil on primed MDF
30 x 25 cm (12 x 10 in)
This subject needs more careful measuring than a simple distant landscape.

OBSERVATION

To be able to paint we must be able to observe. This doesn't mean just seeing our subject. Let me explain. Imagine standing on the side of the road in a town, looking towards the greengrocer's shop next to the baker's on the other side of the road. A mother and child are coming out of the baker's and walking down the street. To paint that scene an artist would see a greengrocer's shop with a green fascia board – with 'Smith's Greengrocer's' lettered across in capital letters painted gold; a window filled with fruit and vegetables and a large display of bananas and oranges outside on the pavement; the mother wearing a blue dress and child with a red tracksuit; the pavement wet after a shower of rain and the reflection of the shops and clothes very pronounced.

When you look at a scene, talk yourself through what you see, like I have just done. If you do this in your daily life, it will become second nature to you and you will have learned another skill – how to observe.

MEASURING

How do you work out the relative sizes and positions of objects in the scene and transpose them accurately on to your paper? Measuring distances and proportions is another important skill to acquire. You may find it a little tedious or mechanical to begin with, but you must persevere. It will soon become second nature, as most of the painting skills do. As you practise you will find that you will learn to judge distances without measuring.

Key measure

The principle is simple. Hold your pencil at arm's length, vertically for vertical measuring and horizontally for horizontal measuring, with your thumb along the near edge as your 'measuring' marker. By always keeping your arm at the same distance from your eye during measuring, the comparative distances will be consistent. The object of the exercise is to measure the subject and apply it to your paper. Obviously you do not use the same length to measure your real life subject as you do for the subject on your paper. You are simply trying to get the correct proportions. You will see this as you go through the exercise on the right. Do practise this, it is very important and it will become very easy to do. By using a key measure on any scene, you can draw as much detail as you like and it will be proportionally correct.

Using a pencil for vertical measuring.

Using a pencil for horizontal measuring.

A Suppose this is a real row of houses and you want to draw houses 1 to 7 on your paper.

B Draw house 3 on your paper. Now hold up your pencil to measure the real house 3, and, as you move your hand along, measure how many widths of house 3 will go into the length of the seven houses (nine). Using your pencil as a scale, measure on your sketch whether the width of house 3 you have drawn fits on your paper nine times. Here it fits only five times.

C Start again and draw a smaller house, and by simple trial and error you will come to the size of house that will fit on to your paper nine times.

D Now hold up the pencil to the real scene to measure how many widths of house 3 can go into houses 1 and 2. You will find they are all the same size. Therefore, on your paper, you can measure three houses from left to right, the third being 3, which is your key measure.

E Look up at your subject again. Measure how many times your key measure goes into house 4 (two). On your sketch, using your pencil as a ruler and your thumb as a marker, measure a distance twice as long as, and to the right of, house 3. This is the correct measurement for house 4. Continue in this way until you have drawn the row of houses from 1 to 7.

F Now check the height of the real life houses. Use your key measure and turn your pencil vertically, with your thumb still in position, to see how many key measures go into its height. You will find that it fits exactly once, up to the bottom of the eaves. Use your key measure to mark the height of the houses on your sketch. Then check the height of the roofs, and so on.

SKETCHING

What is a sketch? A sketch has a definite and important part to play in the creation of a painting. If you are working from your imagination or memory, you will need to put something on paper to start to visualize your thoughts. This can be anything from a few pencil lines on the back of an old envelope to a large canvas. The sketch gathers information from your imagination.

When you are working outdoors and you make a sketch, the objective is just the same; you are gathering information to enable you to work from the sketch back at home or in your studio.

So a sketch is for creating an idea or gathering information. Often students have shown me a painting that is not complete, or lacking in drawing ability, or poorly observed, and have said 'But it is only a sketch'! A sketch is not an excuse for a poor painting.

What size is a sketch?

I usually take my A4 or A3 cartridge sketchbook and a 2B pencil when I go sketching. They are very convenient, easy to carry and you can work almost anywhere with them. If I am going out specifically to sketch for the day, then I will take my watercolours but still work on my cartridge sketchbook. John Constable carried very small sketchbooks with him; the smallest measured 2 x 3 in (5 x 7.5 cm) and he used pencil for these. He also did small oil sketches, 10 x 12 in (25 x 30 cm) and smaller, outdoors. In his studio he would make large oil sketches, some 6 x 4 ft (1.8 x 1.2 m), before he worked on his finished studio paintings.

Is a sketch a painting?

The answer is definitely yes! Sometimes a sketch, especially one done outdoors, can have freedom and spontaneity that can't be achieved

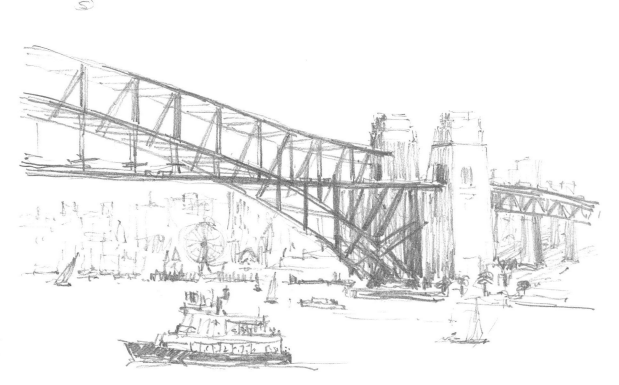

This is an information sketch. Note the position of the sun, marked with an 'S'.

in the studio. Whenever you go out sketching or painting you are going to enjoy creating a picture. If you do a sketch you can put it in an exhibition as a 'painting'. That's exactly what it is – a painting. Many of the old masters' sketches are preferred by critics over their finished paintings. Here I have broken down the sketch into three distinct, practical types.

Information sketch

This is a drawing or painting done solely to collect information or detail, which can be used later at home or in the studio.

Atmosphere sketch

This is a drawing or painting worked specifically to get atmosphere and mood into the finished result. It can be used later for information, or as inspiration for an indoor painting.

Enjoyment sketch

This is a drawing or painting worked on location, done simply to enjoy the experience.

Because of the relaxed mood when you paint an enjoyment sketch, you can often finish up with a brilliant 'painting'. Therefore when sketching in watercolour, never make notes on the front of your sketch: you could easily have a watercolour sketch turn into a masterpiece, so you don't want notes written all over the picture. Put your notes, if you need them, on the back of the sketch.

This is an enjoyment sketch.

This is an atmosphere sketch.

Practical tips

On my sketches I use an S symbol for the position of the sun. This is important because when I want to use the sketch at a later date, if I haven't shown any shadow areas, I will still know the position of the sun. If you are painting an identifiable place, then the sun must be in its correct position in your painting, otherwise you may find that you have painted the sun setting in the east!

The sketches on the following four pages were all done on location, with the excitement and frustration that this brings. But most importantly, each sketch reminds me vividly of a very enjoyable and unforgettable time in my life. Don't forget your sketchbook!

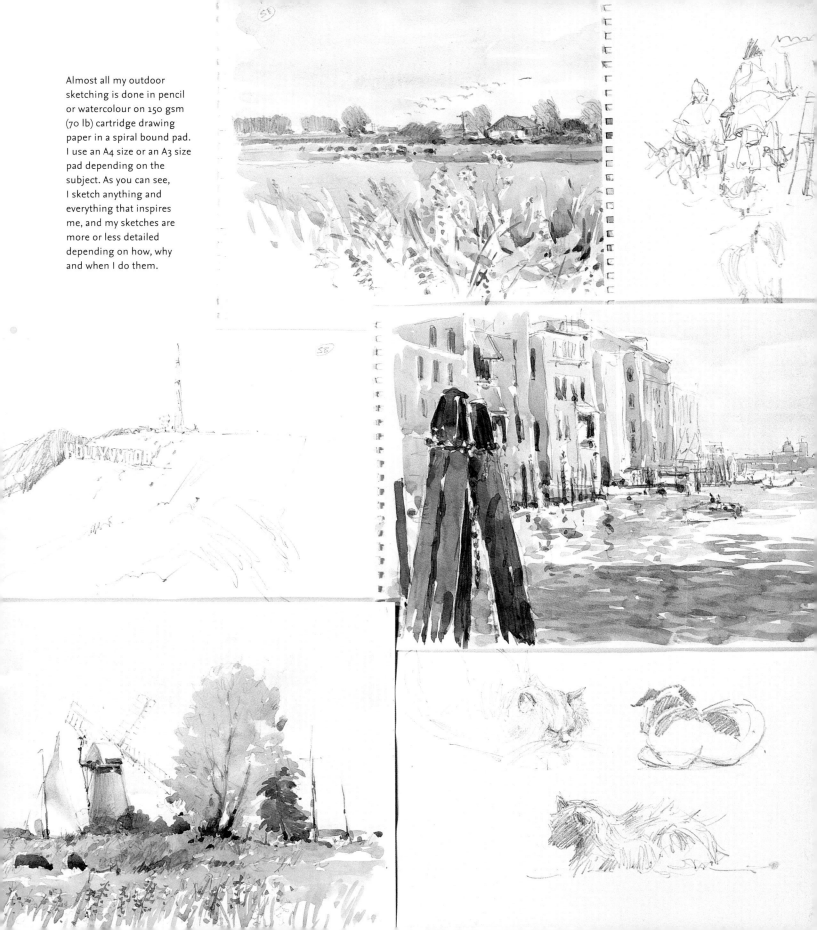

Almost all my outdoor sketching is done in pencil or watercolour on 150 gsm (70 lb) cartridge drawing paper in a spiral bound pad. I use an A4 size or an A3 size pad depending on the subject. As you can see, I sketch anything and everything that inspires me, and my sketches are more or less detailed depending on how, why and when I do them.

WHAT GOES INTO A SKETCH?

What you show in your sketches depends on what type of sketch you are doing. You can spend three hours or three minutes on a sketch, and enjoy both equally.

From the beach – Ibiza

I did this sketch sitting on the beach. It was a hot day and I was inspired by the jumble of boats and the warm colours. This was a pure enjoyment sketch. There was constant movement of boats and people, which I feel I captured, but which is something my photograph couldn't show.

With the photograph for detail and my sketch for atmosphere, I have all I would need to do a larger painting back at home.

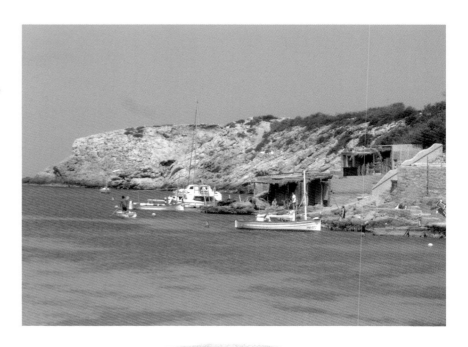

The photo I took from the beach.

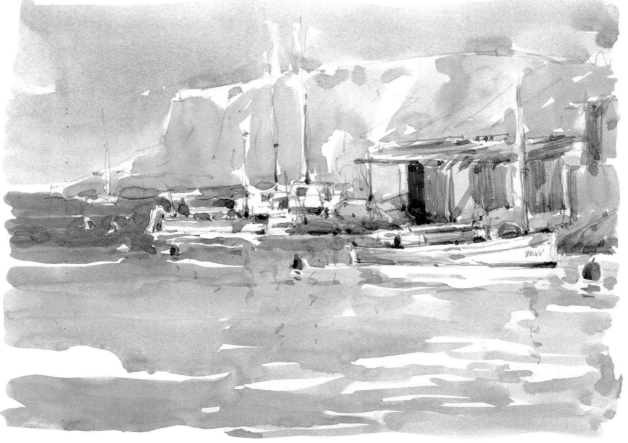

From the Beach, Ibiza
watercolour on
cartridge paper
20 x 28 cm (8 x 11 in)

From the beach – Jersey

There are a few things to notice in this sketch I did when I was sitting on a rock at low tide in a Jersey harbour.

Firstly, the painting has little movement, compared to the Ibiza beach, except the suggestion of the outgoing tide, and there is more careful drawing in the boats, because they are beached.

Also, I painted the red huts on the harbour wall very pale, as otherwise these would have overpowered the boats, which are the centre of interest.

There is always a magical ingredient that you capture when you are working from nature, and above all it is a great teacher. The more you can work from nature, the more you will learn.

A photo of the Jersey harbour.

From the Beach, Jersey
**watercolour on
cartridge paper
20 x 28 cm (8 x 11 in)**

This pencil sketch took me only 20 minutes, but was the starting point for hours of painting pleasure.

RIGHT:
Dedham Church
oil on canvas
25 x 30 cm (10 x 12 in)

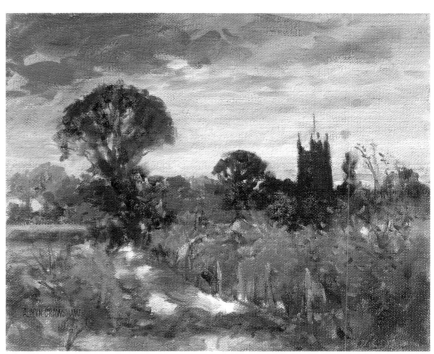

WORKING FROM SKETCHES

It is exciting to come back to your sketches, sometimes even months later, and use them to produce a painting.

Country church

I did this pencil sketch late one evening, when the landscape was almost a silhouette against the evening sky. I didn't have my camera, so my only reference to work from at home was the sketch and, very importantly, my memory. There was very little detail in the silhouette shapes in the pencil sketch, therefore my painting had to be done in the same way. I produced an oil painting first, then a few months later a watercolour. I thoroughly enjoyed doing the pencil sketch, then the oil painting, and much later a watercolour. All this painting pleasure from a 20-minute sketch. Try it yourself!

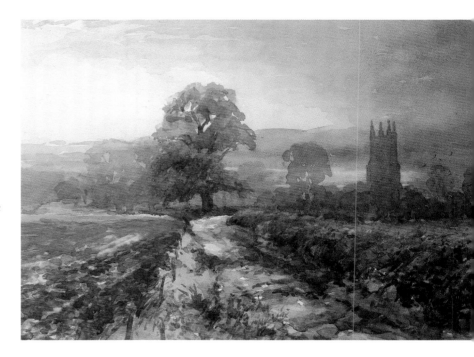

Dedham Church
watercolour on Bockingford
500 gsm (250 lb) Not
35 x 48 cm (14 x 19 in)

Pencil sketch done at the concert, using a 2B pencil on cartridge paper.

The Concert Climax
oil on primed MDF
30 x 41 cm (12 x 16 in)

Concert bowl

This sketch was a real challenge. I went with June and some friends to an evening open-air orchestral concert. I had decided to sketch, but it wasn't easy, with the excited audience waving flags, continually standing up and sitting down, blocking my view, and of course the excitement of the music. This sketching idea was not for the faint-hearted. Naturally I was as excited as everyone else, and so with my adrenaline level very high, I stood up and did my sketch. I also took some not very good photographs.

The climax to the evening was a large firework display working in unison with the orchestra. This was my inspiration for the painting; it was fantastic. Using the sketch, photos and, most importantly, my experience and memory, I painted the oil below.

This is the sketch of the windmill from which I painted the watercolour opposite.

ADDING ATMOSPHERE TO A SKETCH

The skies on the Norfolk Broads are a tremendous inspiration to me. Someone once said, 'When you get into Norfolk, you see one inch of land and 12 inches of sky'. In a landscape painting I believe the sky gives the atmosphere, which sets the mood for the whole painting.

I have sketched the scene for the painting opposite on a few occasions. One of these sketches was done on our boat, moving slowly away from the subject. The great thing about a pencil sketch is that you have usually only gathered visual information of the scene and not the atmosphere, so you can use your creative imagination when you paint from it, adding any atmosphere you want.

Producing the painting

A few weeks before I did the sketch above, we had been caught in a tremendous hailstorm as we were cruising past the windmill in our boat. This lasted for about 20 minutes, and then the blue-black sky broke into fast-moving clouds, allowing the sun to hit the landscape in places

with almost theatrical brilliance. This is how I decided to paint this watercolour, using the sketch for my subject information and my memory for the weather conditions.

I painted the sky first, making sure that the brush strokes were painted in one direction from left to right, and leaving areas of unpainted paper to give the illusion of fast-moving clouds. I then continued making the distant sky very dark with French Ultramarine, Alizarin Crimson and Yellow Ochre, leaving the windmill, the church, the rooftops and sails as unpainted paper. The distant trees were then painted very dark. At one point I thought I had done them too dark, but as I progressed with the painting I decided they contrasted well with the sunlit areas that I worked next.

Then the riverbanks were painted, keeping them dark, and finally the water, which was worked with horizontal brush strokes, leaving natural shapes of unpainted paper to represent movement. I was pleased with the painting, and when I look at it, it brings back very stormy memories!

*Windmill on the River
Thurne, Norfolk*
watercolour on Bockingford
500 gsm (250 lb) Not
35 x 48 cm (14 x 19 in)

Details from the
painting above.

SKETCHING ON THE MOVE

Sketching on the move is a very exciting way to sketch. I have sketched from trains, coaches, cars and boats. Above all it is an excellent exercise for your observation skills.

Speed is of the essence

Don't pick a subject close to you. Sketch something in the middle distance, it will stay in your view for longer. Also sketch with the scene going away from you. Again, it will stay in your view longer, but get smaller as you move away.

These sketches were done very quickly from a moving vehicle. The first sketch was done from a boat. I saw the windmill, which was a definite fixed object, so I drew this in first, then positioned the yacht and the trees. I then drew a line underneath to sit everything on the ground and then finished drawing the sketch.

The next sketch was done when I was riding in a horse-drawn carriage with June in Majorca, when we were filming one of our TV series. We were in traffic and going very slowly and jerkily, and I sketched another horse-drawn carriage, just moving off. Speed was essential. The horse and the people were not drawn, but only shaded straight in with broad pencil strokes. It only took a few minutes, but it kept my drawing skills alive, and I enjoyed doing it.

ALWYN'S TIP

Don't even think of detail, just go for the major shapes and forms. Sketching on the move is excellent for improving your observation skills.

The first stage of my sketch of the windmill.

After sketching the windmill I added the riverbank and trees.

Speed was essential when I sketched this moving carriage.

Boatyard *in oil*

This exercise shows you how I work on an oil sketch outdoors. This sketch was, in fact, done indoors from a pencil sketch, so is a little too 'finished' as it was done in a comfortable indoor environment. It is also missing the flies and other insects that always make a beeline for my wet paint and get stuck!

Stage 1

With a turpsy mix of French Ultramarine and Crimson Alizarin, use your No.6 round brush to draw in the scene.

Stage 2

With your B48 No.4 brush, mix Yellow Ochre with turpentine and paint the sky. Then paint the trees with thicker paint using Cadmium Green and Titanium White. Paint the roof with Titanium White, Crimson Alizarin, Yellow Ochre and a little French Ultramarine. You will find at this stage you have many different mixes of paint on your palette – use them. Paint the buildings, and with a turpsy French Ultramarine paint in more reflections.

Finished painting

Paint over the sky using thicker paint. Add some blue sky at the top and a thick pink at the bottom, using Titanium White and a little Crimson Alizarin. Paint the water using the sky colours, paint the reflections darker and add some light blue between them. Finish the boats and the yacht sail.

◄ Stage 1

◄ Stage 2

▼ *Boatyard*
oil on oil
sketching paper
14 x 18 cm
(5½ x 7 in)

PAINTING FIGURES

When painting outdoors you may want to add figures to your painting. To include people you do not have to be a figure or portrait artist. People are usually secondary in a landscape and are only there to help add atmosphere, life and scale to the painting.

People in watercolour

Here is a simple way of animating people, which helps to make them more believable. Look at the three heads above right. I painted a pink 'egg' first and then with one brush stroke painted the hair. The first has the egg tipped upwards and the hair gives the impression of a side view, looking slightly upwards. In the centre one the egg is upright and the hair makes the 'face' look forward. The one on the right is the opposite of the left-hand face.

If you look at these figures on these pages you will see how the brush stroke for the head gives them life. To paint a person, start at the head and work down the body. Notice how you can let watercolour paint run together (wet-on-wet) as you work down the body.

Look at the figures where I have drawn them and just added pink for the flesh and no hair. Even here the heads show movement. You couldn't suggest them more simply. I added blue for trousers on one of them, and he is even more 'real'. I have taken one group of three and put a dark background behind them, to make them stand out. The two people on their right are an average size for my landscape paintings; they are also reproduced here twice as big to show how simply they are drawn and painted.

Practise drawing first with a 2B pencil. Copy people around you, outdoors and indoors. Get used to their shapes. Then start using only a brush to draw them, in silhouette. You need to practise, but adding people will help to make your paintings really come alive.

The figures on these pages are reproduced actual size. Two of the figures have also been enlarged (above) to show just how simply they were painted.

People in oil

When I paint people in oil and acrylic I use the same principles that I apply to painting them in watercolour.

On these two pages the figures are painted in oil on a dry background. Naturally you will have times when you will paint them on to wet paint. You can see how I have let the background soften the figures in places; this helps to integrate them into the painting, so they don't appear as cut-out figures stuck onto the painting. If you are working on wet paint then it will be easier to merge them with the background.

When painting people in acrylics you can use the watercolour or oil techniques.

ABOVE:
Two of the figures from
the painting on the right
have been enlarged here
to show how simply they
were painted.

HALF-HOUR PAINTING

I have found that many students have difficulty learning how to paint a picture as a whole, in one broad statement, before putting in any detail. The foundation for your painting must be laid first, and then you can build upon it.

It can be very tempting as you paint a sky, for instance, to get excited as you paint a cloud, to keep adding more detail and work to it, almost forgetting that it is only a small part of the painting, and that the rest is still blank paper or canvas! We have all fallen into this trap.

The half-hour exercise will help you to get over this hurdle and also train you in many other very important disciplines. Over the years I have had so many positive results from students after working half-hour exercises, that I believe these are the most important exercises – once you have learned the basics of painting – that you can do. Let's see how they can help.

Observation

With half-hour exercises your observation skills will be sharpened and eventually become second nature.

Simplification

I have said earlier that you can't paint every blade of grass in a field. So you have to simplify. By practising half-hour exercises you will train yourself to paint broad shapes and to stop fiddling with a small brush – especially at the beginning of a painting. Look for and simplify the main features, leaving out any unnecessary detail. Remember, simplify nature in order to paint it.

Form and shape

We talked earlier about tonal values that help us to see the form and shape of objects. Half-hour exercises will help you train yourself to see

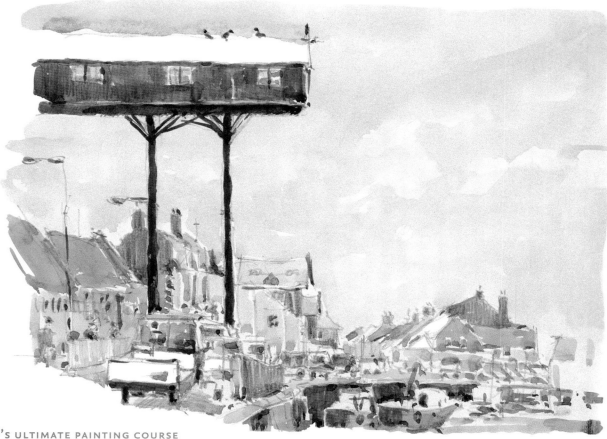

Wells-Next-The-Sea, Norfolk
watercolour on cartridge paper
20 x 28 cm (8 x 11 in)
I wish I had made more room for the foreground – I ran out of paper. I was rushing because of impending rain, which came as I was finishing.

form and shape quickly. Remember, form and shape are seen because objects are light against dark or dark against light.

Speed

Working at speed is not essential for you to paint good paintings, but it is very useful when you are working outdoors where things could move at any moment. The half-hour exercise is the perfect way to practise working at speed. Remember, to work fast outdoors is a bonus.

Discipline

At first you may find that you can't concentrate on a painting for a full half hour, so you will have to keep pushing yourself further in each exercise. The time limit will also train you to have all your equipment at hand before you start. Remember, discipline will help you to get into good habits. It will also make you go out and paint – not go out and think about it!

Planning a half-hour exercise

Remember, the object of the half-hour exercise is to decide what to paint, whether it's an apple or a vast scenic view, and paint everything, yes, everything, in the half hour. It doesn't matter what it looks like, the teaching process is in doing it. Don't cheat yourself, but if it does take another five or ten more minutes, don't worry. Take an extra five minutes or so to observe the scene before you start. If you draw slowly, then don't count the drawing time, only the painting time. Do note down the time before you start, because you will not remember it once you are involved with your painting, when you are concentrating and enjoying doing it.

ALWYN'S TIP

A half-hour painting will make you have a go at painting – not just go out and think about it!

Hickling mill
in watercolour

The building to the right of the windmill in silhouette is where I live and have my studio, therefore I am familiar with this scene. Although this is a simulated half-hour exercise, I timed each stage and it took me 20 minutes. Looking at the finished painting this appears impossible. But let's take it stage by stage.

Stage 1
This drawing is made up of simple shapes. The only accuracy needed is when drawing the mill and buildings. Shade this area with a 2B pencil and quickly draw the lines of the field. Paint the sky in a colour graded wash.

Stage 2
I used my three favourite primary colours for this painting – French Ultramarine, Yellow Ochre and Alizarin Crimson, and the three watercolour brushes I use for all my watercolour painting (page 40). With one wash but changing colour, paint the trees and buildings, then the field.

Finished painting
Paint a wash over the large tree on the left, and paint in the wet mud and foreground. Notice I left a great deal of unpainted paper, especially in the foreground.

I could not have done this exercise if I hadn't been 100 per cent confident in myself. Have a go – I am sure you will surprise yourself.

◀ Stage 1

REPRO, BURN OUT BACKGROUNDS OF ALL STAGES TO WHITE AS SHO

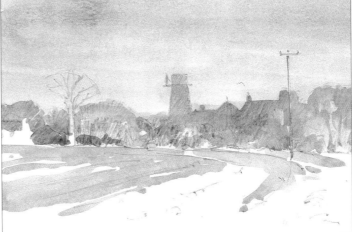

◀ Stage 2

▼ *Hickling Mill* watercolour on cartridge paper 18 x 23 cm (7 x 9 in)

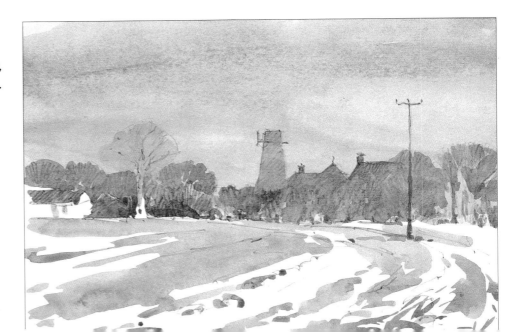

122

Waxham from the dunes *in oil*

An oil painting done as a half-hour exercise will usually take longer than the same scene done in watercolour. This is simply because oil takes longer to mix than watercolour, and its application onto the painting surface is a slower process. I gave the panel an underpainting of acrylic Raw Sienna and Crimson before I began.

Stage 1
Start this exercise using your No.6 round brush to paint in the main lines of composition with a turpsy mix of French Ultramarine and Crimson Alizarin.

Stage 2
Paint the sky with thin paint using French Ultramarine, Crimson Alizarin and Yellow Ochre. At the horizon add Titanium White and use thicker paint. Using your B48 No.4 brush, paint in the distant field and start the sand dunes. Use Titanium White, Yellow Ochre, Crimson Alizarin and Raw Umber, adding French Ultramarine for the dark areas.

Finished painting
Continue painting the sand dunes and then the fields. With the same colours paint the church and houses, leaving some blue underpainting – this helps to give depth to the buildings. Suggest the trees and telegraph poles, and finally paint in the two people coming up the path. Incidentally, this took me 36 minutes. I will try to do better next time!

◀ Stage 1

◀ Stage 2

▼ *Waxham from the Dunes*
oil on canvas panel
23 x 30 cm (9 x 12 in)

EQUIPMENT CHECKLIST

This is a summary of all the equipment you need when you are going to paint outside. Remember always to check you have everything before you venture out, but take only the equipment you need as you may have to carry it a long way.

Watercolour

- Paint box (check colours)
- Brushes (check sizes)
- Pencil (sharpened)
- Eraser
- Water and jar
- Sketchbook/paper
- Paper tissues
- Camera – with film!

Oil

- Paints (check colours)
- Clean palette
- Pencil (sharpened)
- Brushes (check sizes)
- Palette knife
- Eraser
- White spirit
- Low-odour thinners
- Alkyd medium
- Paper/canvas
- Plenty of rags
- Camera – with film!

Acrylic

- Paints (check colours)
- Stay-wet palette
- Brushes (check sizes)
- Pencil (sharpened)
- Eraser
- Water and jar
- Sketchbook/paper/ canvas
- Paper tissues/rag
- Camera – with film!

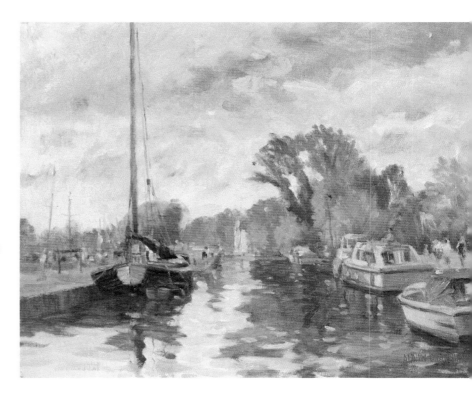

Summertime, Stalham Staithe, Norfolk
oil on canvas
30 x 41 cm (12 x 16 in)

You may also want to take some food and a hot drink, and it is worth carrying your sketchbook in a plastic bag (I dropped mine in a puddle once!). You can take a folding chair or stool and, if you need one, an easel. If you are planning only to sketch in pencil, take just an A4 cartridge pad, a 2B pencil and an eraser.

Once outside

There are important things to consider when you are painting outside. Most of these I covered on pages 98–99, but it is also important that you make yourself comfortable and keep warm while you are working, and if you are in the countryside you must close all the gates. Above all, remember that you are out painting to enjoy it!

Point to Point, Ottery St Mary, Devon
watercolour on Bockingford 500 gsm (250 lb) Not
35 x 48 cm (14 x 19 in)

Martello Tower at Le Hocq, Jersey
watercolour on cartridge paper
20 x 28 cm (8 x 11 in)

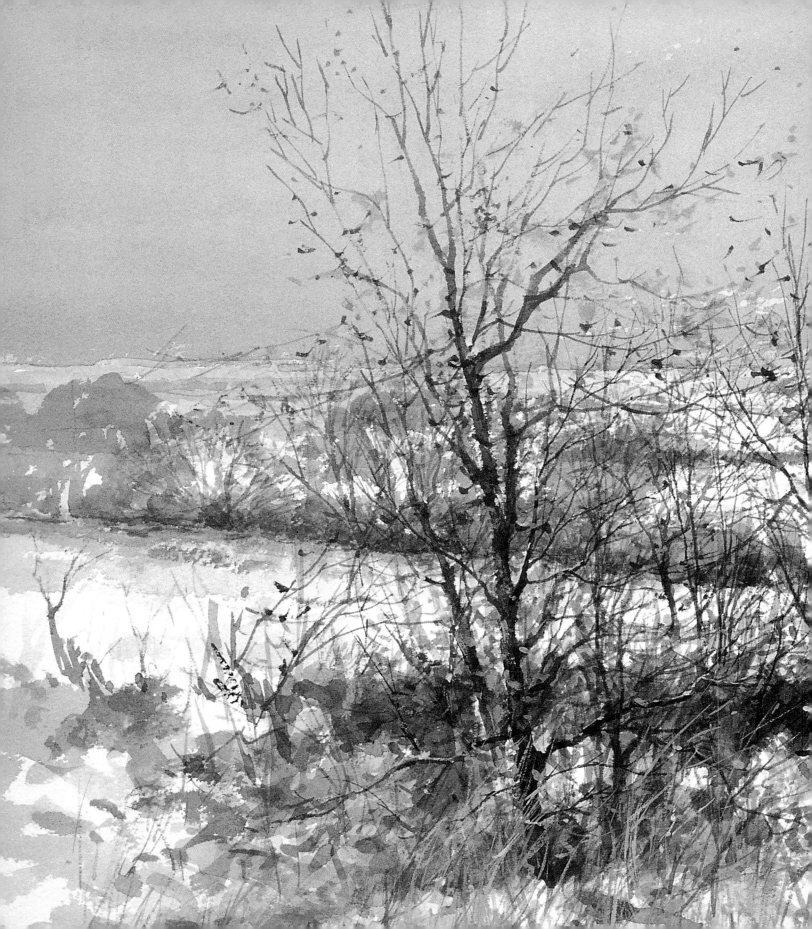

6 Demonstrations

This chapter has many demonstrations for you to copy in each of the different media. Read and look carefully at each demonstration before you start. Familiarize yourself with the subjects as well as the colours and brushes you are going to use. You can paint the demonstrations in any order you like. If you find one difficult, try an easier one and return to the more difficult demonstration when you are feeling more confident.

ABOUT THE DEMONSTRATIONS

If you have been following the sequence of the book, by now you will have already worked on three stage exercises, three colour exercises, sketching and half-hour painting. These and the demonstrations on pages 130–41 are all 'simulated'. I painted the first stage three times, then one of them became the first stage. I then painted over the remaining two and left one of them to become the second stage, and then I finished the painting on the other, making it the third and final stage. Therefore some areas of the paintings are not exactly the same. But the important point is to see the way the painting progresses.

From page 142 the demonstrations are different. A photograph was taken of each stage as I painted it; therefore it is the same painting,

the same brush marks and the exact same colours from the first stage through to the finished stage.

The first demonstration in each medium is an apple and banana still life. I have repeated the subject so that you can see the differences between the different media. Naturally you will find some of the subjects here more difficult to paint than others, but don't worry – try another one, and do them in any order you want.

Remember that we are all unique artists, and as you copy these demonstrations you will find that your paintings will differ from mine in some way. This is because you have put your own painting personality into them. The demonstrations are here to excite and inspire you, and you must allow your own signature to come through during the learning process.

PREVIOUS PAGE:
Winter Chorus
acrylic on Waterford 410 gsm
(200 lb) Rough
51 x 76 cm (20 x 30 in)

*The Grand Canyon,
Arizona, USA*
watercolour on
cartridge paper
28 x 41 cm (11 x 16 in)

OPPOSITE:
*Sitting on the Edge:
The Grand Canyon, USA*
watercolour on
cartridge paper
41 x 28 cm (16 x 11 in)
I did this sitting on the edge
of the Canyon and the paint
was drying almost as soon
as it was put on the paper.
The temperature was in the
high 80°s, but it was a great
and unforgettable experience.
From this I painted an oil
back home in the studio
(page 187).

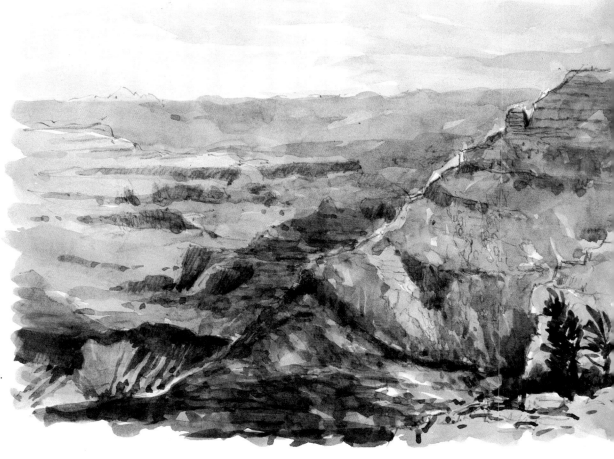

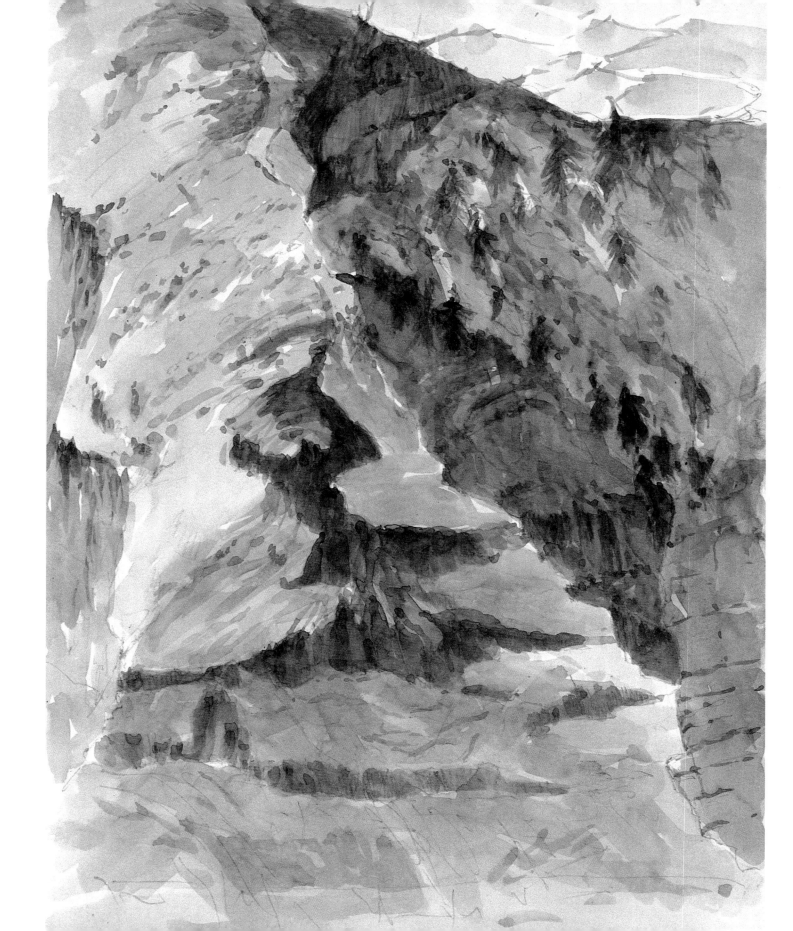

Banana and apple *in watercolour*

Start with this banana and apple. The drawing is relatively simple, so you can concentrate on and enjoy the painting.

Stage 1

Use your 2B pencil to draw the banana and apple. With your No.6 round brush, start on the left of the banana using Cadmium Yellow Pale and add Alizarin Crimson as you work to the right. Add a little Hooker's Green Dark to Cadmium Yellow Pale and work down the apple, adding a little Alizarin Crimson and a little French Ultramarine nearer the bottom. Leave the white highlights unpainted.

Stage 2

When this is dry continue with the same colours to make the dark areas darker. For the dark side of the banana use Yellow Ochre rather than Cadmium Yellow Pale, and add a little French Ultramarine.

Finished painting

Now, with your No.10 round brush, paint in the background, using a watery mix of French Ultramarine and Alizarin Crimson. Let this dry and then, with your No.6 round brush, paint in the shadows (see p.46), the dark markings on the banana, the apple stalk, and darken the bottom of the apple.

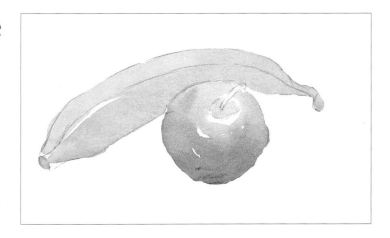

◀ Stage 1

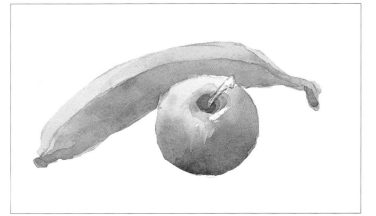

◀ Stage 2

▼ *Banana and Apple* watercolour on Bockingford 410 gsm (200 lb) Not 10 x 18 cm (4 x 7 in)

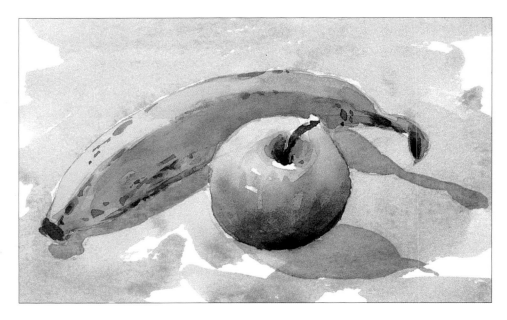

Pigeons
in watercolour

There is a little more drawing needed in this demonstration than the previous one, but the actual painting is easier.

Stage 1
Draw the pigeons with your 2B pencil. With your No.6 round brush, using Hooker's Green Dark, French Ultramarine and Alizarin Crimson, paint in the first three pigeons (wet-on-wet).

Stage 2
Continue with the large pigeon. Notice how I have left small unpainted areas to suggest the direction of the feathers. Now paint their legs and feet, using Cadmium Yellow Pale and Alizarin Crimson.

Finished painting
When these are dry, paint in the darker tonal areas and the dark markings on the pigeons' wings. Now paint their shadows; this sets them firmly on the ground. Finally, put in their eyes. If you are worried about doing this with your brush, you can put them in with your 2B pencil.

◀ Stage 1

◀ Stage 2

▼ *Pigeons*
watercolour on cartridge paper
7.5 x 10 cm (3 x 4 in)

Orange
in watercolour

This is another simple painting exercise. When you have done it, try painting from a real orange segment.

Stage 1
Draw the orange with your 2B pencil. With a mix of Cadmium Yellow Pale and Cadmium Red, paint in the orange, using your No.6 round brush. Leave some white lines (unpainted paper) to help to show the form of the orange.

Stage 2
Let this dry and then paint a pale orange colour between the skin and the fleshy part of the orange. When this is dry, use a darker orange colour to paint over the orange, using downward brush strokes.

Finished painting
Now paint the skin, using more Cadmium Red in your mix. Add a little French Ultramarine, Alizarin Crimson and a little Yellow Ochre, and paint the shadow. Add some shadow colour on the top of each orange segment to give a little detail and form. Notice how I have left pencil lines in this area, which also helps to add form.

◄ Stage 1

◄ Stage 2

▼ *Orange* watercolour on Bockingford 410 gsm (200 lb) Not 7.5 x 10 cm (3 x 4 in)

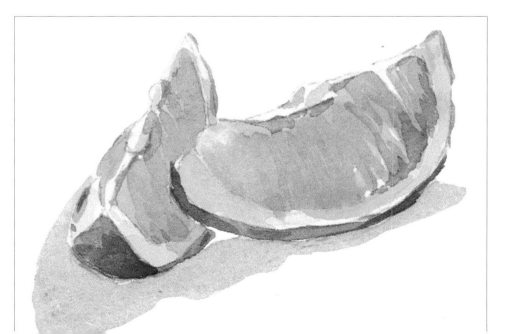

Perch
in watercolour

This exercise is more complicated than the previous ones – even the fish looks worried! – but just take it stage by stage.

Stage 1

Use your 2B pencil to draw the fish. Now, with your No.6 round brush, start with the head, using French Ultramarine and Alizarin Crimson, then work along the body adding Hooker's Green Dark and Yellow Ochre, using plenty of water. Paint the tail and fins with Cadmium Red.

Stage 2

When dry, paint the stripes. Keep them free and loose. Wait for these to dry and using the same colour, but darker, paint over the stripes again. Make them darker at the top, adding water as you work down. Add darker colour to the head and in the open mouth. Paint Yellow Ochre around the eye and lips.

Finished painting

The water is all painted wet-on-wet using your No.10 round brush and a mix of Coeruleum and a little Alizarin Crimson for the lighter areas, adding French Ultramarine, Hooker's Green Dark and Yellow Ochre towards the bottom. Use oval-shaped brush strokes at the top, leaving unpainted paper to give the illusion of light at the surface. Paint over the fish as you go, from the front of the top fin across the body to the tail. Finally, paint the eye and detail on the head.

◀ **Stage 1**

◀ **Stage 2**

▼ *Perch*
**watercolour on
Bockingford 410 gsm
(200 lb) Not
15 x 23 cm (6 x 9 in)**

Banana and apple *in acrylic*

This is the same banana and apple as I used for the first watercolour exercise. It's interesting to see the different approach when you are using acrylics.

Stage 1

Do the drawing with your 2B pencil. Using your B48 No.4 brush and thin paint, paint in the banana with Titanium White, Cadmium Yellow and Raw Sienna. Paint the apple with Titanium White, Leaf Green, Cadmium Red and Cadmium Yellow. Let your brush strokes follow the shape of the apple.

Stage 2

Add darker and stronger colours to the banana and apple, using the same colours as the first stage. Now paint in the background with your B48 No.4 brush using Titanium White, Ultramarine and a little Crimson. Paint this very freely.

Finished painting

Work again on the banana using the same colours as before but darker. Paint in the dark brown markings. Work the same with the apple. Do this with your No.6 round brush. Now, with the same background colours as before, paint the background darker at the top and add shadows. Notice how the brush strokes have helped to give the background movement and make it more interesting. Finally, paint in the apple stalk and put in the highlight on the apple.

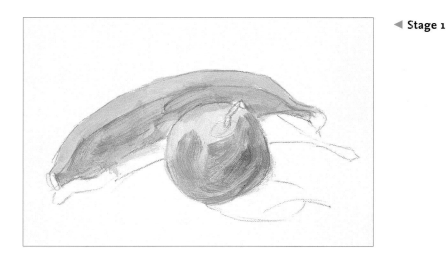

◄ Stage 1

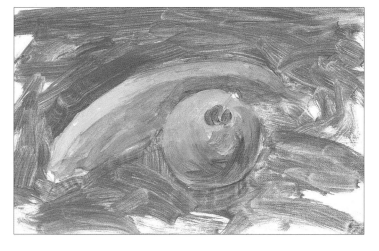

◄ Stage 2

▼ *Banana and Apple*
acrylic on acrylic
sketching paper
13 x 18 cm (5 x 7 in)

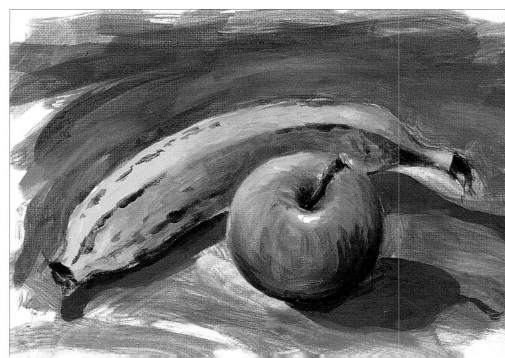

134

Log fire
in acrylic

A log fire can make a good point of interest in a landscape painting as well as adding animation and colour.

Stage 1

Underpaint the board with a wash of Raw Sienna and Crimson. Use your B48 No.4 brush and scumble the sky thinly using a mix of a little Titanium White, Ultramarine, Crimson and a little Cadmium Yellow. With your B48 No.2 brush, paint in the large tree, and dry brush the distant trees.

Stage 2

Paint in the distant fields using Titanium White and Raw Sienna. Continue working down to the foreground using a mix of Leaf Green, Raw Umber, Ultramarine and a little Titanium White. Then paint in the logs using Ultramarine and Crimson. Notice how the brush strokes follow the direction of the path.

Finished painting

Paint the logs darker. Then, with Cadmium Yellow and Cadmium Red, paint in the flames. Use your finger while the paint is wet and smudge the flames upwards. Finish painting the foreground. Finally, with your B48 No.4 brush, delicately scumble in the smoke (see page 64).

▲ **Stage 1**

▲ **Stage 2**

► *Log Fire*
acrylic on Daler Board
18 x 13 cm (7 x 5 in)

Tree in winter *in acrylic*

I love painting trees out of leaf, I feel they have more character and you can see the landscape through them. The more trees you sketch, the more you will understand them, and they are a very important subject for landscape painters to master. When you sketch trees, work first from a distance, then sketch them close up, to observe more detail.

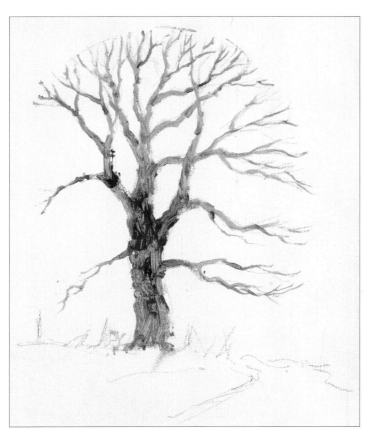

▲ **Stage 1**

Draw the trunk and main branches with your 2B pencil and then paint them using your B48 No.2 brush, No.6 round brush and rigger. Use a mix of Cryla Artists' Heavy Body acrylic colours: Raw Umber, Bright Green, Crimson Alizarin and a little Ultramarine.

▲ **Stage 2**

Now paint in the feathery branches. Use an old brush if you have one, or your B48 No.4, and work a dry brush technique. Let the brush strokes follow the direction in which the branches grow or go. Work over the main trunk. Then paint a suggestion of the grass.

Tree in Winter
acrylic on canvas
20 x 15 cm (8 x 6 in)

▲ Finished painting

This is the exciting part, where you start bringing your tree to life. Use your No.6 round brush and your rigger and paint carefully the small branches at the top of the tree to give it the final shape. Paint some larger branches, light against dark, to give depth to the tree. Next paint some sunlit areas on the trunk. Because acrylic paint dries quickly you can work on the tree continuously, until you feel you have added enough detail and it is finished.

Always put something in your paintings to give scale to a tree. Here I have suggested a fence.

Banana and apple *in oil*

Here is the same banana and apple as I painted in watercolour and acrylic. If you use oils, try this demonstration.

Stage 1

Draw the shapes with your 2B pencil. Paint over this with the No.6 round brush and a turpsy mix of French Ultramarine and Crimson Alizarin, and paint in the shadows. Now, using your B48 No.2 brush, paint the banana using Titanium White, Cadmium Yellow and Crimson Alizarin and a little French Ultramarine.

Stage 2

Work from the top of the apple with your B48 No.2 brush, using Cadmium Green and Titanium White, adding Cadmium Yellow and Crimson Alizarin as you work down. Use thin paint and let your brush strokes follow the shape of the apple. Add French Ultramarine for the darker areas.

Finished painting

Paint in the background with your B48 No.4 brush using Titanium White, French Ultramarine and Crimson Alizarin. Don't paint over your shadow areas. Now paint over the banana using the same colours as before, but thicker paint. Work the apple the same way. Now paint the dark marks on the banana and the stalk on the apple. Paint the shadows with a B48 No.2 brush. Note how I added a Crimson area to the apple shadow and a little Yellow Ochre to the banana shadow. Finally, add the white highlight on the apple.

◀ Stage 1

◀ Stage 2

▼ *Banana and Apple*
oil on oil sketching paper
13 x 18 cm (5 x 7 in)

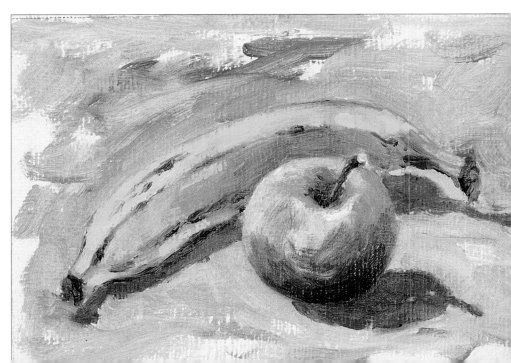

Fishing boat
in oil

Try this simple boat. I have not added any detail, but the movement of the water and the reflections bring the painting alive.

Stage 1
Using a turpsy mix of French Ultramarine and Crimson Alizarin, and your No.6 round brush, draw in the main features. Still using thin paint, paint in the riverbank with your B48 No.4 brush using French Ultramarine, Crimson Alizarin and Yellow Ochre. Using the same colours but darker, paint the boat. Use Cadmium Red for the bow.

Stage 2
Paint the riverbank again, this time using thicker paint. Now paint the men and the boat's outboard motor using your B48 No.2 brush.

Finished painting
With a mix of Titanium White, French Ultramarine, Crimson Alizarin and a little Yellow Ochre, paint in the water with your B48 No.4 brush, using horizontal brush strokes. Use your B48 No.2 brush to paint in the reflections, merging them together as they get near the boat. This can be done with your finger or brush. Notice how I dragged some 'water' over the yellow reflection, and the way the water swells up at the back of the boat. Make sure your brush strokes go in this direction. Finally, paint the red life jackets on the men, their hair and the cap.

◀ Stage 1

◀ Stage 2

▼ *Fishing Boat*
oil on primed
Bockingford 500 gsm
(250 lb) Rough
10 x 13 cm (4 x 5 in)

Still life *in oil*

This colourful still life is more of a challenge. Look and read through the stages carefully first. Try to paint it in your mind's eye. When you feel familiar with the painting, you can make a start. If you do find it difficult, move on to another exercise, and come back to it when you are feeling more confident.

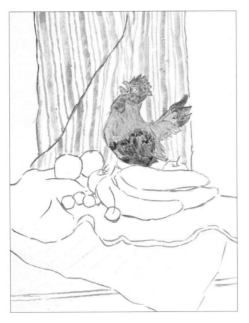

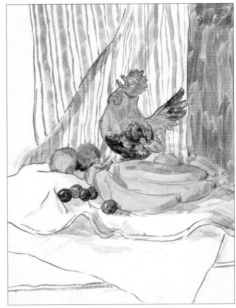

▲ **Stage 1**

Draw your main shapes with a 2B pencil. Then paint over the pencil using your No.6 round brush. Don't use any white paint in this stage or Stage 2. To make the colours lighter use more turpentine (low-odour thinners). Use your B48 No.4 brush to paint the pink stripes using Cadmium Red and French Ultramarine, the cockerel's head using Cadmium Red, add Yellow Ochre to this and paint the body, and finally paint the lower body and tail with French Ultramarine.

▲ **Stage 2**

Continue using a turpsy mix and paint the fruit. Use your B48 No.4 brush with a mix of Cadmium Yellow and a little Cadmium Red for the bananas. With your B48 No.2 brush and the same colours, paint the nectarines and cherries, adding French Ultramarine for the darker areas. With French Ultramarine and Cadmium Red, paint in the shadows and dark area in the background, using your B48 No.4 brush.

◄ Finished painting

Now mix white with your colours to make them lighter. Using your B48 No.2 brush mix Titanium White, a little French Ultramarine and a little Cadmium Red, and paint over the white areas in the cloth (vary the colour). Then paint over the pink stripes. Now paint the cockerel, again adding Titanium White to the colours. Let your brush strokes follow the shape of the feathers. Now paint the fruit. Notice how the red from the cherries is reflected in the banana. Paint the 'white' and the shadows on the tablecloth, then the blue design and stripes. Paint over the two dark areas in the background using French Ultramarine, Cadmium Red and Raw Umber and a little Titanium White. Finally, paint in the wooden table top and the dark area underneath.

Still Life
oil on canvas panel
41 x 30 cm (16 x 12 in)

Detail reproduced
actual size.

Snow *in watercolour*

I love painting snow, especially in watercolour. I have painted snow outdoors, but obviously working in the studio is warmer and more comfortable! However, the outdoor work is important as it enables you to observe and feel the atmosphere. If it's at all practical, do try it. Each stage of this demonstration was photographed as I painted it.

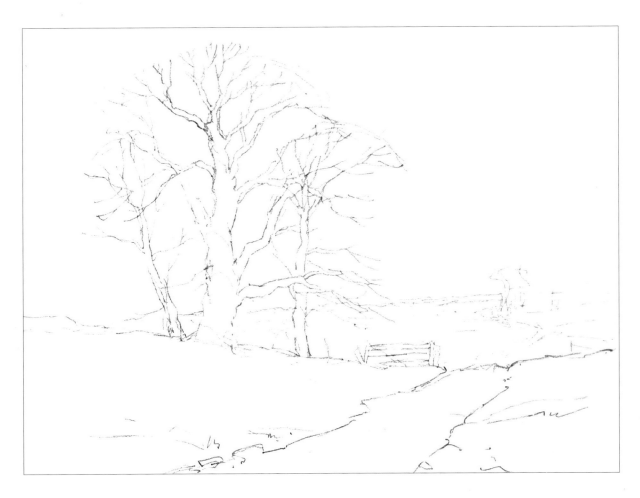

▲ **Stage 1**
With your 2B pencil draw the main hillside on the left and the path. Now draw the distant 'horizon' line. These are the main construction lines. Now draw the main group of trees. When drawing or painting trees always start at the bottom and work up and outwards, the way the tree grows. Finally, draw in any details that will help you when you paint. I didn't draw in the people, as I wasn't sure at this stage exactly where they would go.

▲ Stage 2

The first thing to establish, especially when you are painting a landscape indoors, is where the sun is. In this painting it is on the left, casting shadows on the right of objects.

Start by painting the sky. Don't paint over the trunks and main branches of the large trees. Use your No.10 brush and work wet-on-wet, starting with French Ultramarine, then adding water, then Yellow Ochre, adding Alizarin Crimson as you work down to the horizon and paint down and over the distant trees. While this is still wet add a brush stroke of French Ultramarine at the horizon.

This will merge with the 'pink' colour to give some atmosphere in the distance. As you paint the sky there will be small areas of white paper left where the brush missed. These are fine, they help to give life to your watercolour. They are not mistakes! At this stage the sky is very wet. You must wait until it dries before you begin the next stage.

Detail of Stage 2.

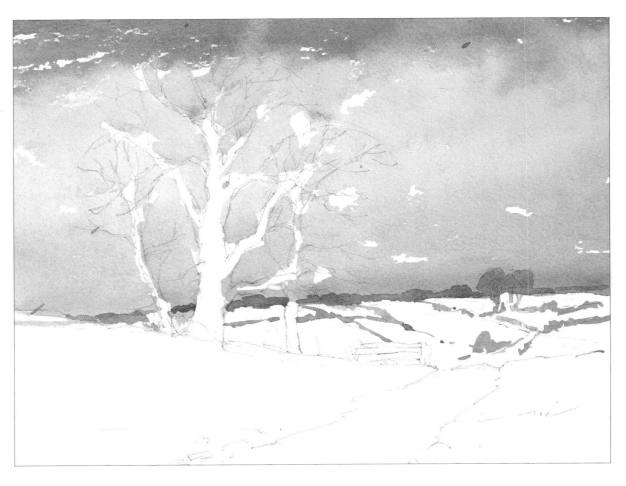

▲ Stage 3

This stage is important because it creates the illusion of distance. The distant trees and hedges are a little warmer than in a daytime scene because of the reflected warm light from the setting sun.

When the sky is totally dry, with a mixture of French Ultramarine, Alizarin Crimson and a little Yellow Ochre, use your No.6 brush to paint the distant trees and hedges. Keep the paint very wet and don't fiddle! At this stage the snow is unpainted paper.

Detail of Stage 3.

▲ Stage 4

Use your No.6 brush with a mix of Cadmium Yellow Pale and a little Hooker's Green Dark to paint the trunk of the middle tree from the bottom upwards. Leave white paper at the base to represent snow. Add a little Alizarin Crimson and French Ultramarine as you work up the trunk and the branches. Use your rigger brush for the small branches. Then paint the left-hand tree using your rigger brush. Use a mix of Yellow Ochre and Alizarin Crimson. With the same brush, but with a mix of French Ultramarine, Alizarin Crimson and a little Yellow Ochre, paint the right-hand tree.

Now, with your No.10 brush, mix Yellow Ochre and Alizarin Crimson. With the paint very watery, paint the feathery branches of the left-hand tree, starting at the top, and adding a little French Ultramarine as you paint down and work over the trunk and branches. With the same colours but more French Ultramarine, paint the feathery branches of the middle tree and then the right-hand tree, using more Yellow Ochre and Alizarin Crimson. Finally, suggest the hedge under the trees.

Detail of Stage 4.

▲ Stage 5

This is the exciting part: painting the snow. Remember that your painting will not look the same as mine: don't worry, just use it as a guide.

Before you start, mix Yellow Ochre and Alizarin Crimson and paint the mud on the path with free brush strokes. Now mix a watery mix of Coeruleum in your palette. With your No.10 brush, start at the top left of the field and using broad brush strokes following the contour of the field, work down. Add French Ultramarine and a little Yellow Ochre as you get nearer to the bottom, leaving plenty of unpainted paper. Let this stage dry.

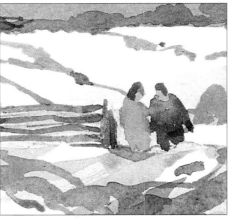

Detail of finished painting showing how simply the people were painted (see p. 116).

▲ Finished painting

Start by darkening the distant trees on the left of the big trees. Then add a little more dark to the main trees and a little detail. Next, paint in the two people with your No. 6 brush – notice how they are talking to each other. With the same brush, paint the gate. Now fully load your No.6 brush with a watery mix of French Ultramarine, Alizarin Crimson and a little Yellow Ochre and paint in the trees' shadows. The brush strokes must follow the contours of the ground. With the same colour paint shadows on the lumps of snow in the foreground. Now add any dark accents and detail.

Snow
watercolour on
Bockingford 410 gsm
(200 lb) Not
24 x 28 cm (9½ x 11 in)

Koi carp *in watercolour*

I am sure you will enjoy painting these colourful Koi carp. Because the first stage is painted wet-on-wet, you can relax while you are painting it and enjoy the way the colours mix and merge together. This is one of the great beauties of watercolour painting. Naturally, your wet-on-wet will not look the same as mine.

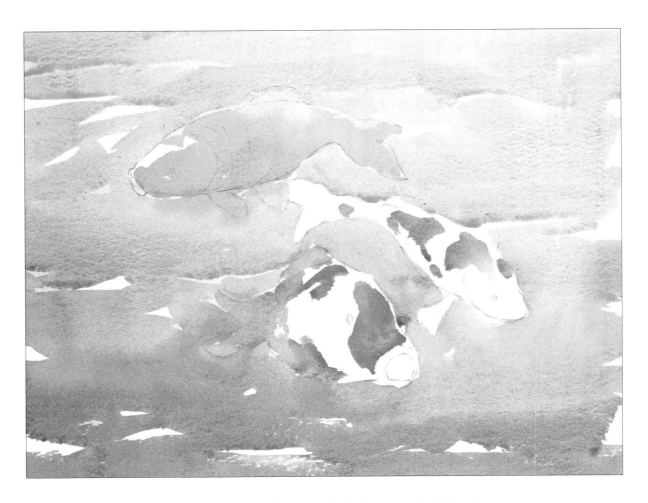

▲ **Stage 1**

Draw the fish with your 2B pencil. Mix some watery colours in your palette: Coeruleum; French Ultramarine with Alizarin Crimson; Hooker's Green Dark; Cadmium Yellow Pale with a little Cadmium Red; Cadmium Red. Start at the top with your No.10 brush and work down wet-on-wet. When you come to a fish, paint it. Colours will run, but in places where you don't touch the next colour you will have a clean, crisp line.

▲ Stage 2

Leave to dry, then, with a varying mix of Yellow Ochre, Cadmium Red and French Ultramarine, paint the fins and underside of the top fish darker. To show a soft edge where you start on the Koi's back, start with water and add colour as you go. Now paint in the dark blue markings on the front fish and darken all the fins and tails. Paint a wash of Yellow Ochre and Alizarin Crimson in the open mouth of the front fish. Finally, add some grey tone to the two front fish, using French Ultramarine, Alizarin Crimson and a touch of Yellow Ochre. All this stage is painted using your No. 6 brush.

Once you have started, make sure you aren't interrupted or you will lose the spontaneity and rhythm of the painting. As when you painted the snow, your painting will have passages that are not like mine. Enjoy the freedom of painting with watercolour.

Detail of Stage 2.

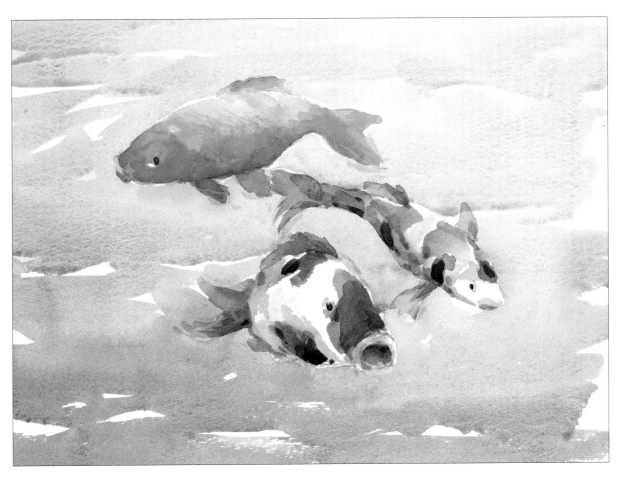

▲ Stage 3

Use your No.6 brush for this stage. Add darker tones to the top fish in the same way that you did in the last stage. Leave a small light area around the eye. Paint the tail of the middle fish darker and add some dark markings. Make the dark markings on the front fish darker and make the red markings stronger (redder). Add more dark to the inside of the front fish's open mouth and a little Yellow Ochre watered down for the lips. Finally, paint in the eyes on all three fish using a dark colour. Now you can take a short break before you begin painting the final stage.

Detail of finished painting showing how the black of the fish's eye has a highlight. This is white paper that I was careful not to paint over.

▲ Finished painting

The object of the last stage is to darken the water and go over the fish in places. Notice how the back of the front fish is still left as white paper, but I painted over the lower part of it at this stage, which helps to put it in the water. Look at your painting and decide where you will paint

over the fish. Then get the same colours mixed in your palette as you did in the first stage. Have another look at the painting to decide what you're going to do, and paint from top to bottom. When dry, use a bristle brush to lift out paint to suggest scales on the top fish. Finally, put in any detail you feel your painting needs.

Koi Carp
watercolour on
Bockingford 410 gsm
(200 lb) Not
23 x 28 cm (9 x 11 in)

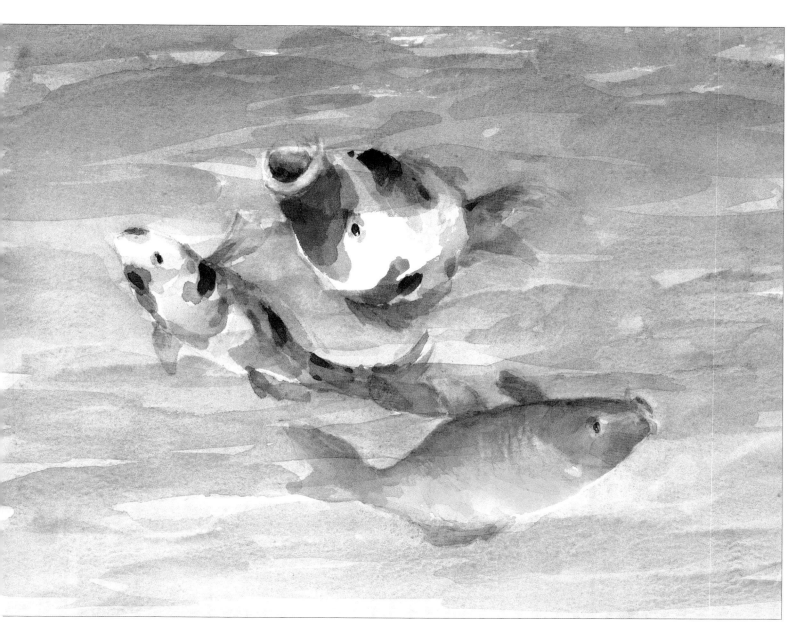

The blue door *in oil*

On a bright summer's day I was inspired by the dark shadows and bright sunlight in
the garden and on the blue door at the back of our house. I rushed into the studio to fetch
my easel to set up in our paddock. This demonstration was done outdoors with the flies,
bees and butterflies as my only students. I took photographs of each stage as I painted it.

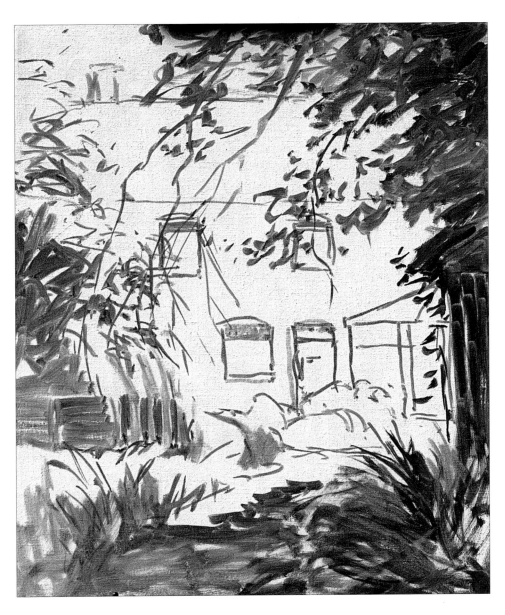

◀ **Stage 1**

Using your No.6 round brush and
a turpsy mix of French Ultramarine and
Crimson Alizarin, start by positioning
and drawing in the door. This is
important as it is the centre of interest.
Then draw the building and windows.
Paint the branches (use your rigger
brush for these) and foliage, freely but
controlled. Add a little Crimson Alizarin
to the mix and paint the end of the
building on the right. Finally, paint
in the wooden fence on the left.

Detail of Stage 2.

▲ **Stage 2**

Now, with your B48 No.6 brush, paint the house, using a mix of Titanium White, Cadmium Yellow and Cadmium Red. Keep the paint thin so that it dries easily, as you will need to paint the foliage over the top.

Paint the sky with Titanium White and French Ultramarine, and then darken the windows. Next, with your B48 No.2 brush and a mix of French Ultramarine, Viridian and a little Crimson Alizarin, paint in the dark foliage on the right and the foreground dark grasses. Continue, painting in the sunlit green areas.

Notice I have left unpainted canvas at this stage to show any areas in bright sunlight.

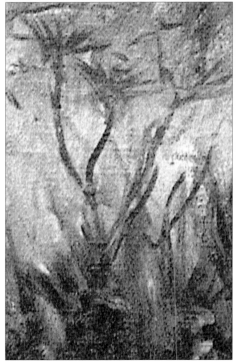

Details of Stage 3.

▲ Stage 3

With your No.6 round brush, paint in the blue door with Coeruleum and Titanium White. Now, using your B48 No.2 brush and a varying mix of Titanium White, Cadmium Green and Cadmium Yellow, paint the sunlit green areas. Using your rigger brush, paint back the branches of the tree on the left. Keep the paint runny and not thick for these lines. Still using your rigger brush, paint the dark grasses in the foreground, going over the light green areas. Paint the brush strokes for all the branches and grasses in the direction they grow or go.

Details of finished
painting.

▶ Finished painting

This stage in a painting, particularly one like this, is very exciting. Colour, tone and design are now developed over the whole painting, and you can emphasize or minimize any elements you like.

With your No.6 round brush, suggest window and door frames and put some highlights on the blue door. Cover up most of the sky around the chimney stack with tree foliage (this was distracting). Now, with thick paint, using Titanium White, Cadmium Green and Cadmium Yellow, paint in the sunlit foliage on the left. Curve the brush strokes towards the centre of the painting. This is to create a 'hole' to look through at the blue door. The light colour green on the left foreground also leads your eye to the blue door. This is a typical example of how nature can make a good design.

Notice how the two top windows have almost disappeared. But because they were painted before the foliage was done, you can still see a suggestion of windows. This helps to give depth to the painting. Finally, with your No.6 brush, and using a variation of greens, suggest leaves and grasses in the foreground.

OPPOSITE:
The Blue Door
oil on canvas
51 x 41 cm (20 x 16 in)

Early start, Potter Heigham *in oil*

In this scene I like the quiet, serene atmosphere of the early spring day, which doesn't seem disturbed by the activity on the yachts, apart from the 'wallowing' movement of the foreground water. Nature's composition also works well in this painting: the river takes your eye into the painting and the main yacht is the focal point.

▲ Stage 1

Give the canvas a wash of acrylic Raw Sienna before you start painting. Draw the scene with your 2B pencil, or draw it straight in with your No.6 round brush using a turpsy mix of French Ultramarine and a little Crimson Alizarin. Draw a line across for your eye level, then the left-hand buildings, then the right-hand ones, and finally draw the yachts. Remember with oil paint you can change areas by wiping off the paint or over-painting. This can help if your drawing isn't exactly as you would like it to be the first time.

▲ Stage 2

With your B48 No.6 brush and a mix of Titanium White, French Ultramarine and Crimson Alizarin, start at the top of the sky and paint down, adding a little more Titanium White and Crimson Alizarin towards the horizon. Work with the paint thin, so the Raw Sienna underpainting shows through in places.

With your B48 No.2 brush and a mix of Titanium White, French Ultramarine, Crimson Alizarin and Yellow Ochre, paint in the distant trees and buildings. With the same colours but stronger (less white) paint the buildings and boats on each side of the river. Use Titanium White, Coeruleum and a little Crimson Alizarin for the left-hand boats.

With the same brush, paint the tree trunk, using your rigger brush for the smaller branches. With a mix of Titanium White, Cadmium Green, a little Yellow Ochre and Crimson Alizarin, paint the foliage, going over some of the branches as you work.

Detail of Stage 2.

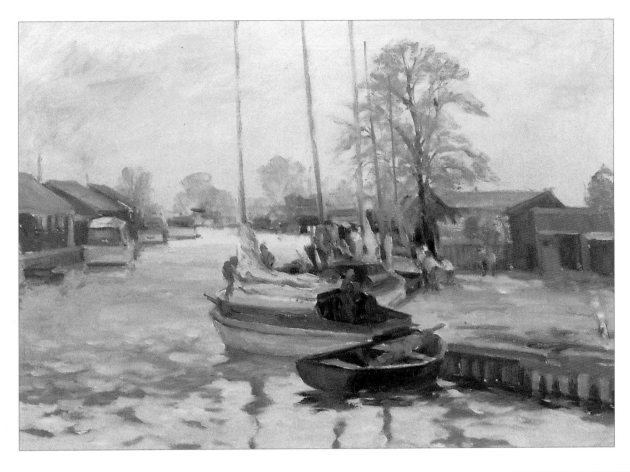

▲ Stage 3

With a turpsy mix of the tree foliage colour with French Ultramarine added, paint a wash on the river with your B48 No.6 brush, using horizontal brush strokes, from the boat on the left downwards. This is the dark colour you can see in the foreground water. Now paint the river, starting at the top, using your B48 No.2 brush to start, changing to your No.4 as you work down. With a mix of Titanium White, French Ultramarine, Crimson Alizarin and Yellow Ochre, keep the brush strokes horizontal and in the foreground make them short, leaving the underpainting showing in places. Now paint the yachts, grass and people.

▶ Finished painting

Continue to add more modelling to the foreground yacht. Use your No.6 round brush to paint the three fenders on the side and the windows in the cabin. Make the second yacht more pronounced by darkening the cabin sides. Don't be tempted to put any more work into the background, or it will not stay down the river. Remember that a little 'mystery' in a painting is a good thing.

Leave finishing the masts until last, because it would be impossible to do any more work in between the masts and rigging lines once they are done. Use your No.6 round brush for the masts and your rigger for the rigging lines (this is what

Detail of finished painting.

the rigger brush was originally made for, hence the name). To help you see exactly what I have done, look carefully at the details which are reproduced here the same size as I painted them.

This is not the easiest of the demonstrations, but have a go, you will enjoy the challenges and I am sure you will surprise yourself. Good luck.

Early Start, Potter Heigham
oil on canvas
30 x 41 cm (12 x 16 in)

Detail of finished painting.

French fruit stall *in acrylic*

Your drawing skills are very important for this painting. If you don't feel confident about drawing, leave this demonstration for later as there are plenty of others to copy that use fewer drawing techniques. On the other hand, why not try it – it could be easier than you think. Remember, it's always a good idea to stretch yourself.

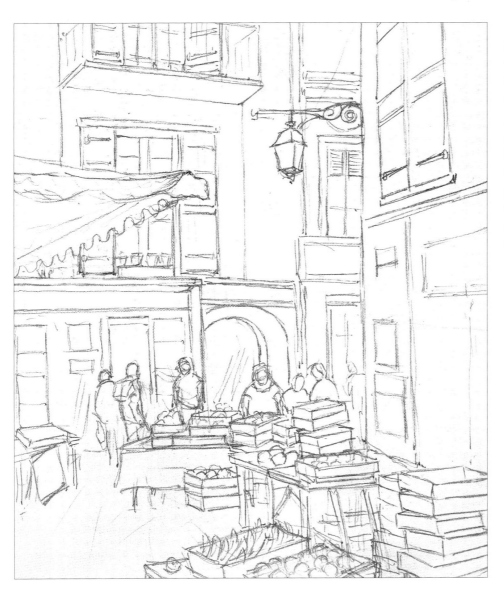

◀ **Stage 1**

Draw the scene with your 2B pencil. Start with the main construction lines of the buildings. Don't even think about detail yet. Draw the verticals of the two main buildings. Now draw in the windows and shutters and the doors on the ground level. Now draw in the boxes – note how they are not standing straight and neat – give them movement. Draw some fruit in the nearer ones. Suggest the people and the wrought iron lamp. Finally, draw in the canopy on the left.

Detail of Stage 2.

▲ Stage 2

Work this painting using thin, watery acrylic paint for most of the painting. For the walls of the buildings in this stage use a variation of colours – Raw Sienna, Crimson, Cadmium Yellow and Ultramarine. Mix these on the palette to give varying colours as you paint. For the green shutters use Coeruleum Blue and a little Cadmium Yellow. Use your B48 No.4 brush for all this work. At this stage your palette will have many subtle colours mixed from when you worked the colours for the buildings. Don't wipe them off your palette; you can use them in the next stage.

Detail of Stage 3.

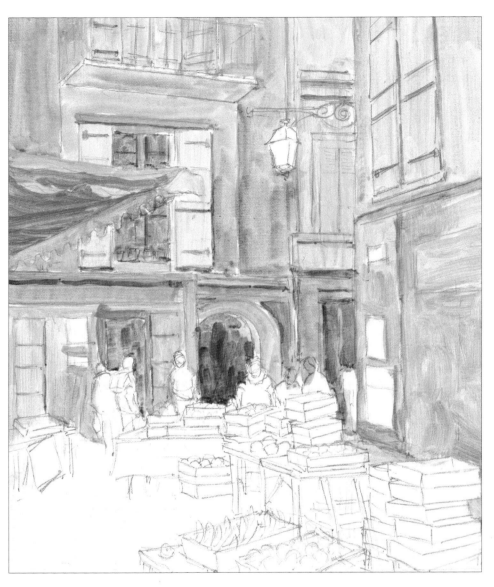

▲ Stage 3

Using your B48 No.4 brush continue painting the buildings, using the colours you used in Stage 2. Start painting in the top windows and then the window with yellow shutters, using Ultramarine and a little Crimson. With the same colour, paint in the doorway underneath, then the archway to the right of it. Now, with your No.6 round brush, put in some shadow lines on the shutters, and on the building behind the lamp. When you are painting the buildings, don't be too precise, and change the colours in a subtle way. This will help to keep the buildings 'alive'.

Detail of Stage 4.

▲ Stage 4

Paint in the fruit boxes with a mix of Cadmium Yellow and Titanium White with your No.6 round brush. Now, with your B48 No.4 brush, paint in the ground using Ultramarine, a little Crimson and a little Raw Sienna. Paint the brush strokes in perspective; this makes the ground appear flat. Paint the shadows on the boxes, and the table legs.

With your No.6 round brush, paint the heads and arms of the people, using Cadmium Red and a little Cadmium Yellow and Titanium White. Don't overwork the people and don't forget to animate their heads (see p.116).

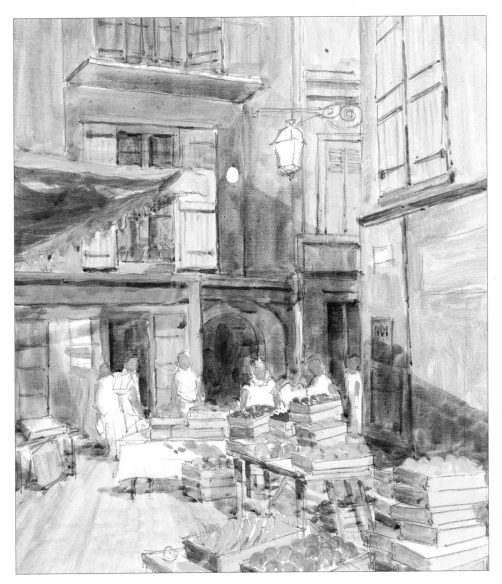

▶ **Finished painting**

Paint the wrought iron lamp using your rigger brush and paint the railings on the balcony with the same dark colour, but a little lighter. Remember to make the paint watery for thin lines. Add some more detail to the fruit and boxes and any other detail you feel you need on your painting. Then, with your No.6 round brush, paint in the hair on the people and their clothes.

Finally, I decided to make the canopy darker to make it stand away from the yellow shutters. A 'busy' painting like this could be worked on further to create a more detailed painting. If you feel like putting more work into it, then do, and enjoy it.

OPPOSITE:
French Fruit Stall
**acrylic on acrylic
sketching paper
25 x 22 cm (10 x 8½ in)**

▲ **Stage 5**

Now paint the shadows on the buildings. This is very important as it gives dimension to the painting. Notice how the people and the fruit boxes stand out against the dark shadow (light against dark). Make a watery mix of Ultramarine, Crimson and a little Raw Sienna and, using your No.6 round brush, start at the top of the shadows (under the balcony) and work down, getting a little darker. Continue with the same shadow colour and paint shadows under the tables. With the same brush, paint the fruit. Don't try to add detail to the fruit: it is the shapes and colours that are most important.

Thurne Dyke *in acrylic*

This is a scene I know well. I sketched it from the riverbank looking towards Thurne Dyke on the Norfolk Broads, and copied it from my sketch when I did the painting. Compared with the previous demonstration, the drawing required is negligible. The distant objects are painted very freely but give the impression of this being a very busy area.

▲ **Stage 1**
Draw the main features with your 2B pencil. Primed MDF wears the pencil point down very quickly, making it difficult to produce thin lines. Don't worry, because in a painting like this you do not need to draw any precise lines. In fact, this could just as successfully be drawn with paint and a No.6 round brush.

Detail of Stage 2.

▲ Stage 2

Now start the sky, using your B48 No.6
brush. Paint in the 'blue' sky first, with
Ultramarine and Crimson and a little
Titanium White. Then paint the darker
clouds, adding Raw Sienna to the blue
sky colour. Add more Raw Sienna and
Titanium White to the top left clouds.
With a mix of Titanium White, Raw
Sienna, Cadmium Yellow and a little
Crimson, paint the distant light-coloured
clouds, leaving spaces for the light blue
sky. With Titanium White and Coeruleum
Blue, paint the distant blue sky. If the
paint dries too quickly, scumble over the
clouds in areas to blend them together.
Work the sky down part of the buildings.

Use your B48 No.2 brush for the
remaining work in this stage. Start with
the trees on the right, using a mix of
Ultramarine, Crimson, Raw Sienna and
Titanium White, and work to the left.
As you paint the trees, change the colours
and tones to give variation, which helps to
add life to them. The buildings' roofs are
Cadmium Red, Cadmium Yellow and
Titanium White.

It is important when painting a scene
like this that you keep all the mixed, 'dirty'
colours on your palette because these are
the colours that help you to paint subtle
colour changes as you work the area. Next,
paint the start of the distant field, using
Titanium White, Raw Sienna and a little
Leaf Green.

▲ Stage 3

Continue painting the distant field, varying the colour. Paint a dark area across it to give the impression of a raised bank. Next, paint in the puddles with a very watery mix of Ultramarine and a little Crimson, using downwards brush strokes. With a varying mix of Leaf Green, Raw Sienna, Crimson, Ultramarine and Titanium White, paint the main field from the top. Use short brush strokes and paint to the right, as if the wind is blowing the grass from left to right. Now paint the path with a mix of Raw Sienna, Ultramarine, Crimson and Titanium White, also using some of the 'grass' colours left on your palette. Make the brush strokes follow the path, and paint around and into the blue puddles.

▶ Finished painting

Using your No.6 round brush, paint in the windmill and yacht sails with Titanium White, a little Ultramarine, Crimson and Raw Sienna. Add details – yacht masts, darks and light accents. For the yacht masts use your rigger brush.

Now paint in the cows, using your No.6 round brush with Cadmium Yellow, Crimson and a little Titanium White. Then, with your rigger brush, paint in the gate and fence.

Finish by putting in some dark shadows on the path to give the impression of lumps of clay, and finally paint in the birds to the right of the windmill. Do this with your No.6 round brush in just two brush strokes – one for each wing.

Detail of finished painting.

Thurne Dyke
acrylic on primed MDF
25 x 30 cm (10 x 12 in)

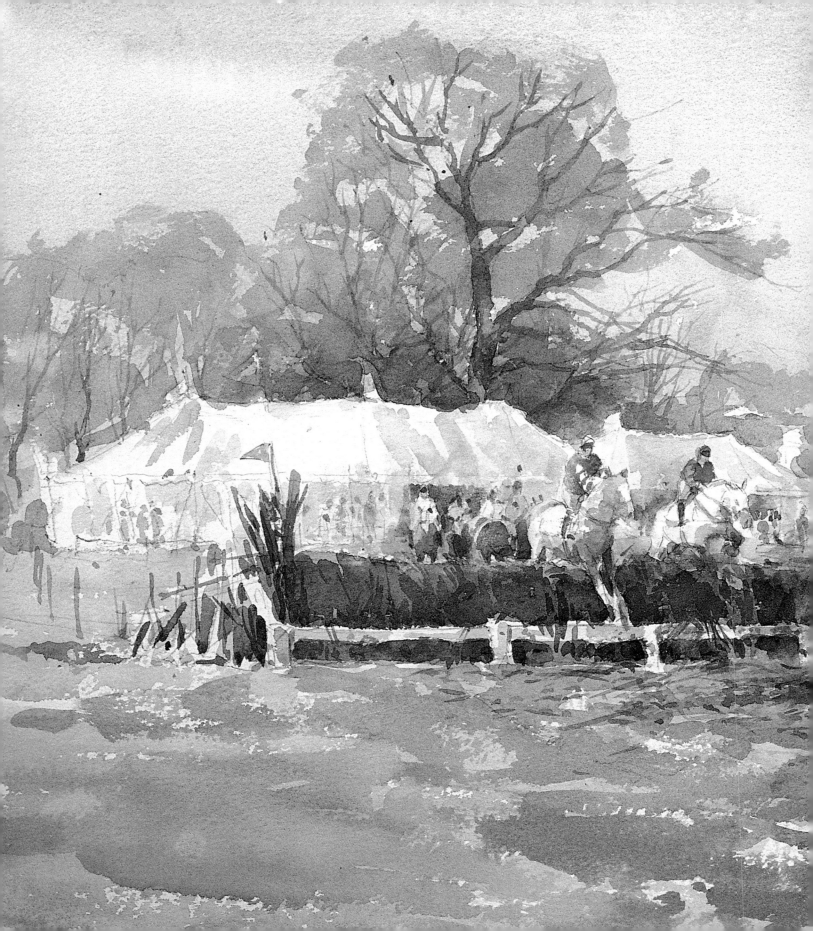

7 Gallery

Each painting in this gallery has a story to tell. Looking through
them brings many memories flooding back. Naturally I have
some favourites amongst them, which are not necessarily the
best paintings. A favourite is created by different circumstances.
It could be where it was painted, the company you were with,
the subject matter, the ease with which you painted it, or simply
that it was the result of a very pleasurable day. I hope you enjoy
looking at these as much as I enjoyed painting them.

Brixham Harbour, Devon
oil on canvas
51 x 76 cm (20 x 30 in)

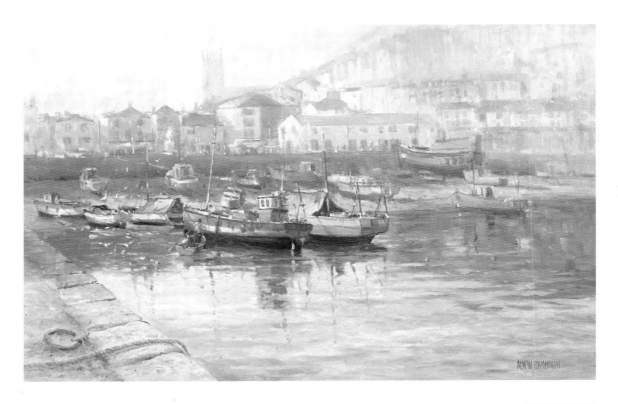

Barges, Pin Mill, Suffolk
watercolour on Bockingford
500 gsm (250 lb) Not
35 x 48 cm (14 x 19 in)

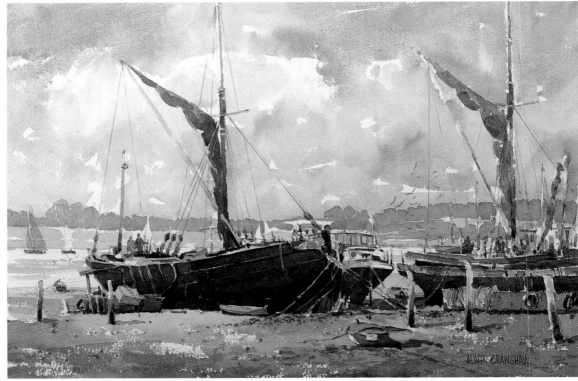

PREVIOUS PAGE:
Three in the Lead,
Ottery St Mary
watercolour on Bockingford
410 gsm (200 lb) Not
35 x 48 cm (14 x 19 in)

St Aubin's Harbour, Jersey
oil on canvas
76 x 102 cm (30 x 40 in)

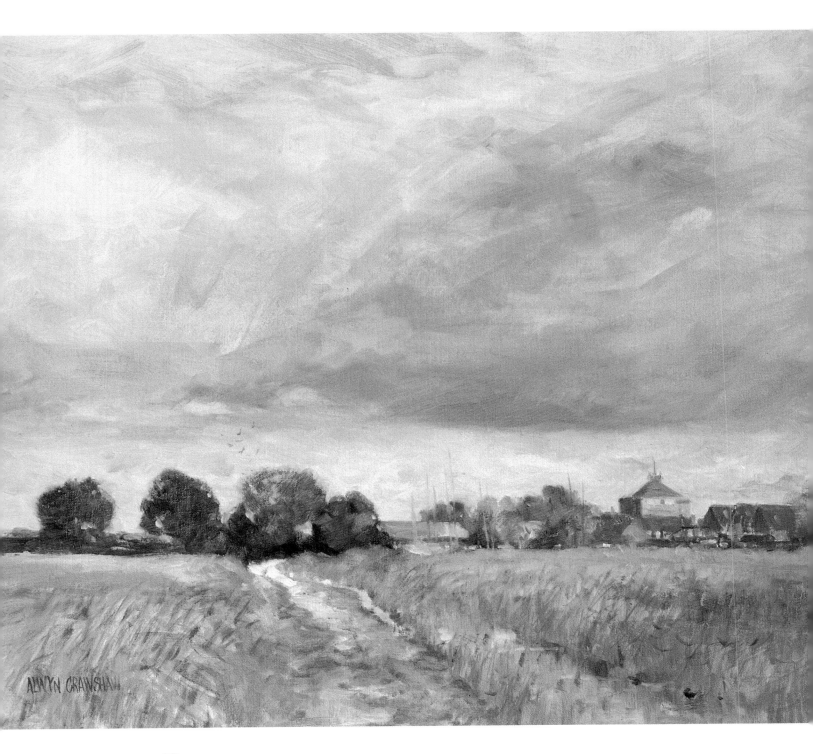

Potter Heigham, Norfolk
oil on canvas
41 x 51 cm (16 x 20 in)

*Looking Towards
Downtown Los Angeles*
watercolour on
cartridge paper
20 x 28 cm (8 x 11 in)

*River Katsura,
Arashiyama, Japan*
watercolour on
cartridge paper
28 x 41 cm (11 x 16 in)

Winter Sunset
watercolour on Bockingford
410 gsm (200 lb) Not
35 x 48 cm (14 x 19 in)

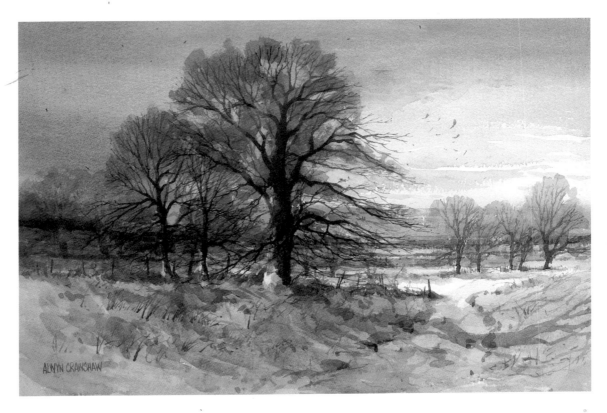

Winter Walk
watercolour on Bockingford
410 gsm (200 lb) Not
35 x 48 cm (14 x 19 in)

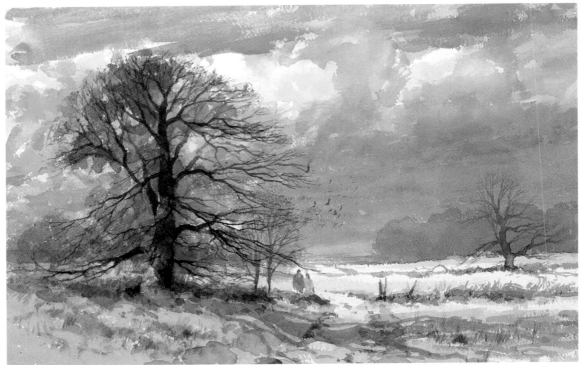

Not Far Now
watercolour on Bockingford
500 gsm (250 lb) Not
35 x 48 cm (14 x 19 in)

Winter Marshes
acrylic on Bockingford
500 gsm (250 lb) Not
35 x 48 cm (14 x 19 in)

From the Beach,
Le Hocq, Jersey
watercolour on
cartridge paper
20 x 28 cm (8 x 11 in)

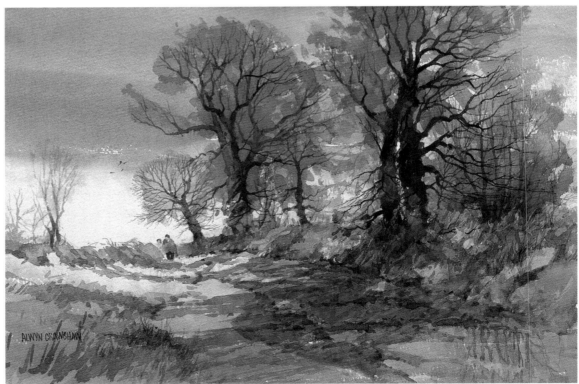

Country Lane
watercolour on Bockingford
500 gsm (250 lb) Not
35 x 48 cm (14 x 19 in)

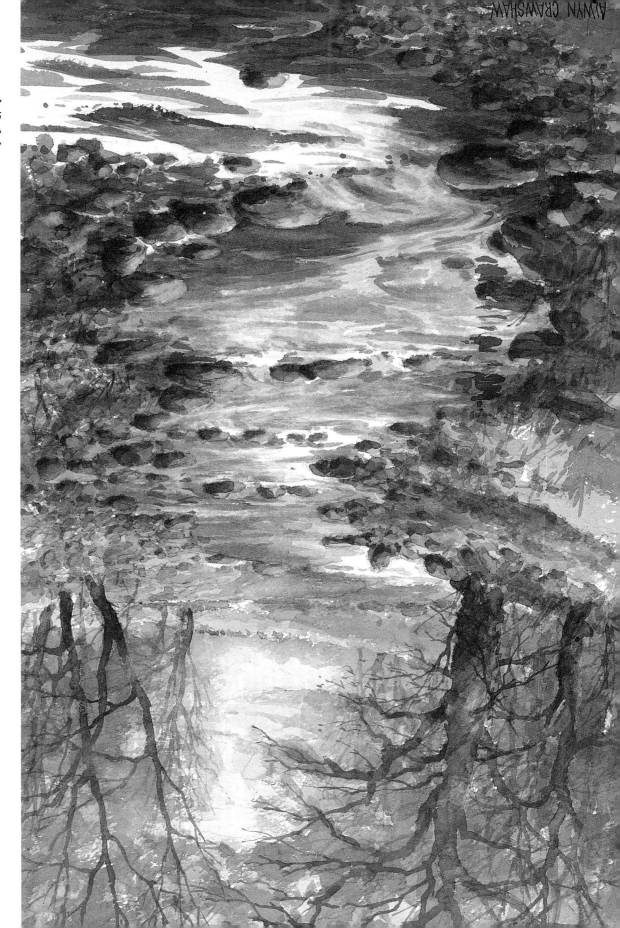

ALWYN CRAWSHAW

A *Yorkshire Stream*
watercolour on Waterford
500 gsm (250 lb) Not
48 x 35 cm (19 x 14 in)

Sunlight, Venice
watercolour on Bockingford
500 gsm (250 lb) Not
35 x 48 cm (14 x 19 in)

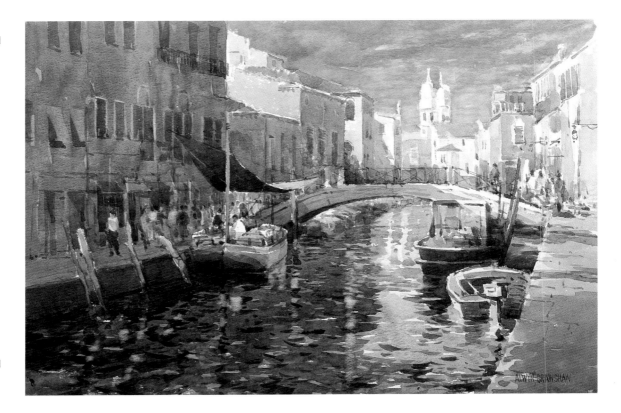

BELOW:
*Three Rivers Race, Potter
Heigham, Norfolk*
watercolour on Bockingford
410 gsm (200 lb) Not
35 x 48 cm (14 x 19 in)

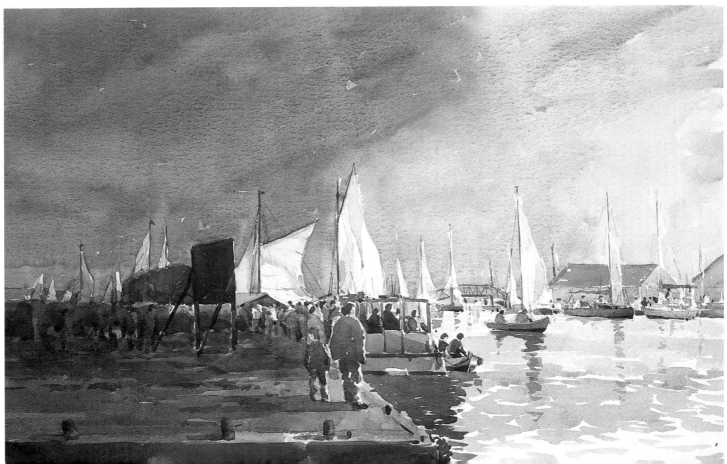

*Looking Towards
my Studio, Hickling*
watercolour on
Bockingford 410 gsm
(200 lb) Not
35 x 48 cm (14 x 19 in)

BELOW:
*Breydon Water,
Norfolk*
oil on canvas
51 x 61 cm (20 x 24 in)

Peaceful Mooring
oil on primed MDF
25 x 30 cm (10 x 12 in)

Evening Light, Hickling Broad, Norfolk
watercolour on Bockingford
500 gsm (250 lb) Not
51 x 76 cm (20 x 30 in)

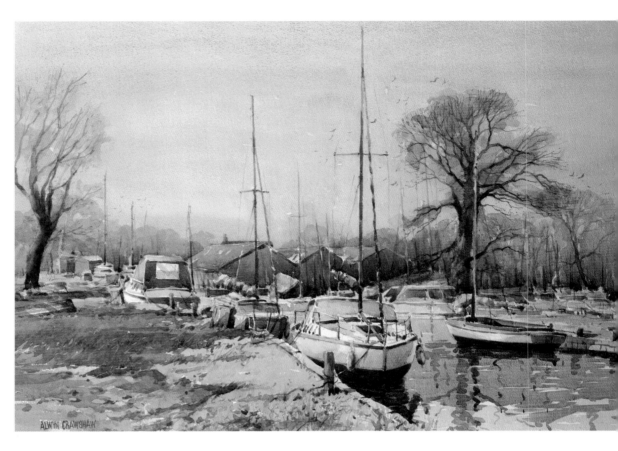

Mud at Morston Quay, Norfolk
acrylic on primed MDF
25 x 30 cm (10 x 12 in)

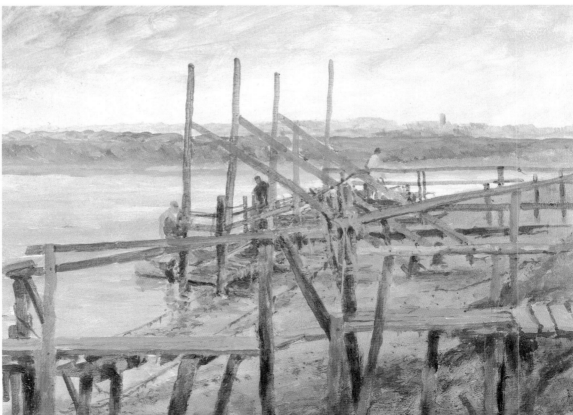

Boats, Hickling Broad
oil on canvas
41 x 30 cm (16 x 12 in)

And the Sun Came Out,
Big Ben, London
watercolour on Bockingford
500 gsm (250 lb) Not
35 x 48 cm (14 x 19 in)

After the Shower,
Big Ben, London
watercolour on Bockingford
500 gsm (250 lb) Not
35 x 48 cm (14 x 19 in)

ALWYN CRAWSHAW

The Grand Canyon,
Early Evening
oil on primed MDF
41 x 30 cm (16 x 12 in)

Winter on the Broads
oil on canvas
51 x 76 cm (20 x 30 in)

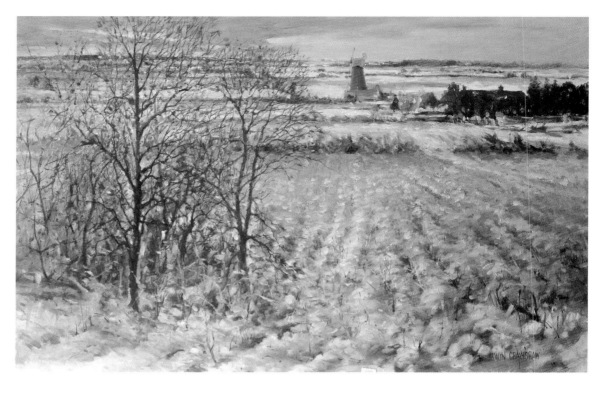

BELOW:
River at Cley-Next-The-Sea, Norfolk
oil on primed MDF
41 x 30 cm (16 x 12 in)

ABOVE:
Mist at Pin Mill, Suffolk
oil on canvas
51 x 76 cm (20 x 30 in)

Donkeys at Hydra, Greece
oil on primed MDF
30 x 41 cm (12 x 16 in)

ABOVE RIGHT:
Hide and Seek
acrylic on Bockingford
500 gsm (250 lb) Not
25 x 35 cm (10 x 14 in)

ABOVE:
The Greyhound's Bertie
acrylic on primed MDF
41 x 30 cm (16 x 12 in)

Taking it further

There is a wealth of further information available for artists, particularly if you have access to the internet. Listed below are just some of the organizations or resources that you might find useful.

ART MAGAZINES

The Artist, Caxton House, 63/65 High Street, Tenterden, Kent TN30 6BD; tel: 01580 763673
www.theartistmagazine.co.uk
Artists & Illustrators, 226 City Road, London EC1V 2TT; tel: 020 7700 8500
www.aimag.co.uk
International Artist, P. O. Box 4316, Braintree, Essex CM7 4QZ; tel: 01371 811345
www.artinthemaking.com
Leisure Painter, Caxton House, 63/65 High Street, Tenterden, Kent TN30 6BD; tel: 01580 763315
www.leisurepainter.co.uk

ART MATERIALS

Daler-Rowney Ltd, P. O. Box 10, Bracknell, Berkshire RG12 8ST; tel: 01344 461000
www.daler-rowney.com
T. N. Lawrence & Son Ltd, 208 Portland Road, Hove, West Sussex BN3 5QT; tel: 0845 644 3232 or 01273 260260
www.lawrence.co.uk
Winsor & Newton, Whitefriars Avenue, Wealdstone, Harrow, Middlesex HA3 5RH; tel: 020 8427 4343
www.winsornewton.com

ART SHOWS

Artists & Illustrators Exhibition, 226 City Road, London EC1V 2TT; tel: 020 7700 8500 (for information and venue details)
www.aimag.co.uk
Patchings Art, Craft & Design Festival, Patchings Art Centre, Patchings Farm, Oxton Road, Calverton, Nottinghamshire NG14 6NU; tel: 0115 965 3479
www.patchingsartcentre.co.uk
Affordable Art Fair, The Affordable Art Fair Ltd, Unit 3 Heathmans Road, London SW6 4TJ; tel: 020 7371 8787
www.affordableartfair.co.uk

ART SOCIETIES

National Acrylic Painters' Association, 134 Rake Lane, Wallasey, Wirral, Merseyside CH45 1JW; tel: 0151 639 2980
www.napauk.org
Royal Institute of Oil Painters, Mall Galleries, 17 Carlton House Terrace, London SW1Y 5BD; tel: 020 7930 6844
www.mallgalleries.org.uk
Royal Institute of Painters in Water Colours, Mall Galleries, 17 Carlton House Terrace, London SW1Y 5BD; tel: 020 7930 6844
www.mallgalleries.org.uk
Society for All Artists (SAA), P. O. Box 50, Newark, Nottinghamshire NG23 5GY; tel: 01949 844050
www.saa.co.uk

BOOKCLUBS FOR ARTISTS

Artists' Choice, P. O. Box 3, Huntingdon, Cambridgeshire PE28 0QX; tel: 01832 710201
www.artists-choice.co.uk
Painting for Pleasure, Brunel House, Newton Abbot, Devon TQ12 4BR; tel: 0870 44221223

INTERNET RESOURCES

Alwyn Crawshaw: the author's website, with details of his books, videos and prints, and a gallery of his original paintings
www.crawshawgallery.com
Art Museum Network: the official website of the world's leading art museums
www.amn.org
Artcourses: an easy way to find part-time classes, workshops and painting holidays
www.artcourses.co.uk
The Arts Guild: on-line bookclub devoted to books on the art world
www.artsguild.co.uk
British Arts: useful resource to help you to find information about all art-related matters
www.britisharts.co.uk
British Library Net: comprehensive A-Z resource including 24-hour virtual museum/gallery
www.britishlibrary.net/museums.html
DiscountArt: the UK's largest on-line art and craft supplier
www.discountart.co.uk

Galleries: the UK's largest-circulating monthly art listings magazine, with details of exhibitions and other art services
www.artefact.co.uk

Galleryonthenet: provides member artists with gallery space on the internet
www.galleryonthenet.org.uk

Jackson's Art Supplies: on-line store and mail order company for art materials
www.jacksonsart.com

Open College of the Arts: an open-access college, offering home-study courses to students worldwide
www.oca-uk.com

Painters Online: interactive art club run by The Artist's Publishing Company
www.painters-online.com

WWW Virtual Library: extensive information on galleries worldwide
www.comlab.ox.ac.uk/archive/other/museums/galleries.html

VIDEOS

APV Films, 6 Alexandra Square, Chipping Norton, Oxfordshire OX7 5HL; tel: 01608 641798
www.apvfilms.com

Teaching Art, P. O. Box 50, Newark, Nottinghamshire NG23 5GY; tel: 01949 844050
www.teachingart.com

FURTHER READING

If you have enjoyed this book, why not have a look at some of the other art instruction titles that are available from Collins?

The Artist **magazine**, *The Artist's Watercolour Problem Solver*
Artists' Rescue Tactics
Bellamy, David, *Coastal Landscapes*
Painting Wild Landscapes in Watercolour
Crawshaw, Alwyn, *Alwyn Crawshaw's Oil Painting Course*
Alwyn Crawshaw's Watercolour Painting Course
Learn to Paint Acrylics
Learn to Paint Landscapes
Learn to Paint Oils for the Beginner
Learn to Paint Outdoors in Watercolour
Learn to Paint Sketch
Learn to Paint Watercolours
You Can Paint Landscapes in Watercolour
You Can Paint Watercolours
Crawshaw, June, *You Can Paint Seashore in Watercolour*
Harrison, Don, *Don Harrison's Top Watercolour Techniques*
Jennings, Simon, *Collins Artist's Colour Manual*
Collins Complete Artist's Manual
King, Ian, *Gem Watercolour Tips*
Watercolour Landscape Techniques
Lidzey, John, *Watercolour Workshop*
Shepherd, David, *Painting with David Shepherd*
Simmonds, Jackie, *Gem Sketching*
Watercolour Innovations
Stevens, Margaret, *The Art of Botanical Painting*
Soan, Hazel, *Gem 10-minute Watercolours*
Secrets of Watercolour Success
Trevena, Shirley, *Vibrant Watercolours*
Waugh, Trevor, *Winning with Watercolour*
Whitton, Judi, *Loosen up your Watercolours*

For further information about Collins books visit our website:
www.collins.co.uk

Index

Page numbers in **bold** refer to captions